ARNOLD FLATEN, SCULPTOR

ARNOLD FLATEN

SCULPTOR

AUGSBURG PUBLISHING HOUSE

MINNEAPOLIS, MINNESOTA

ARNOLD FLATEN, SCULPTOR

Copyright © 1974 Augsburg Publishing House

Library of Congress Catalog Card No. 74-14168

International Standard Book No. 0-8066-1452-8

Frontispiece: *Create in Me a
Clean Heart*. Chapel reredos,
panels in oak. St. Paul's
Lutheran Church, La Crosse,
Wis.

Manufactured in the United States of America

954630

CONTENTS

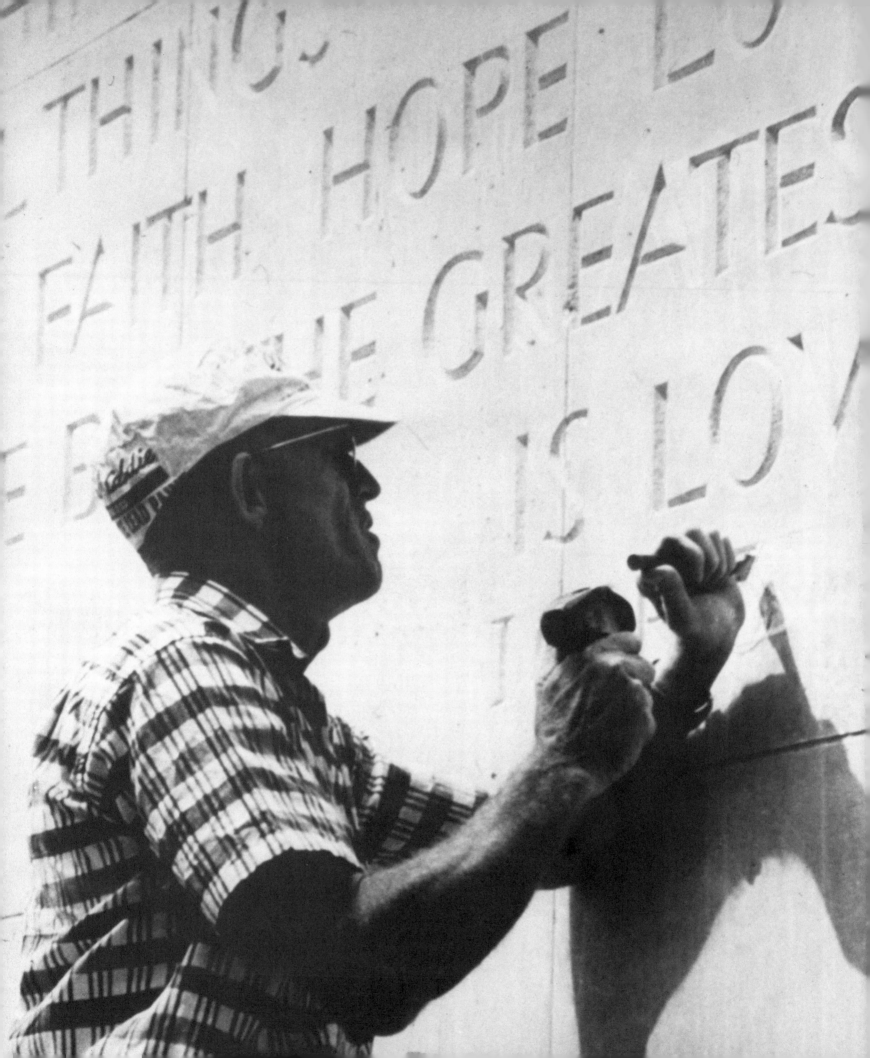

As a student at St. Olaf, I knew Arnold Flaten as teacher and artist. I now know him as artist and teacher. In all likelihood, he was always the artist-teacher. I have come to learn how passionately these vocations have been experienced by a truly reverent and loving man.

Arnold Flaten is an individual whose spirit, thoughts, and actions combine to produce a wholeness not usual to the human conditon. As artist and individual, he expresses a presence which reflects a unique completeness. His work in sculpture and painting makes manifest a life-celebration in devotion and action.

When I was a student at St. Olaf, Arnold Flaten brought me to an awareness of nature that I had never experienced in spite of the fact that I grew up in the farms of southern Minnesota. He opened himself to the world of nature. As artist, he celebrates not nature, but God's grace in nature. There is a quality of humble triumph in his art. His carvings are found forms, personal in their experience.

Arnold Flaten's world is centered in the theology which formed the foundation of his education. He has never departed from his mission as preacher, even in his stay in Paris to seek the content in aesthetics related to his theology. Arnold Flaten has never substituted aesthetics for religion. The uniqueness of his talent lies in this simple truth. To him, art has been a living existential truth expressed in personal terms. He authenticates the religious by that which he touches in his art.

As phenomenology, Arnold's art has the quality of revealed experience which transcends the ontic truth of art as artifact. The ontological truth of object in art is its reason for being in the world. Nowhere is this truth more clearly shown than in the carvings of his favorite passages from the Bible. The mystery of art is revealed in the extension of meaning of the words through the experience of being carved in wood by the artist's hand. It is this extension which gives celebration and revealed truth to the written word. The "coming into being" with the experienced object transcends its rational objectivity.

I am never tempted to comment on the craft of Arnold's work. Nor am I tempted to look for style or continuity. His works are there and, as objects, they transcend style and the mechanics of craft.

For Arnold Flaten, art is not used. In a manipulated society of postured cultural images, he gives to the art object an authenticity borne not in cultural convention but in lived un-self-conscious reverence.

Art becomes revealed experience. It is this poetic quality which springs autonomously from the artist's hand that characterizes Arnold Flaten's work in its quiet, unconscious innocence: it dignifies and gives credibility to man's existence.

2. Arnold Flaten carving
1 Corinthians 13 on exterior wall of St. Paul's Lutheran Church, La Crosse, Wis. Kasota stone.

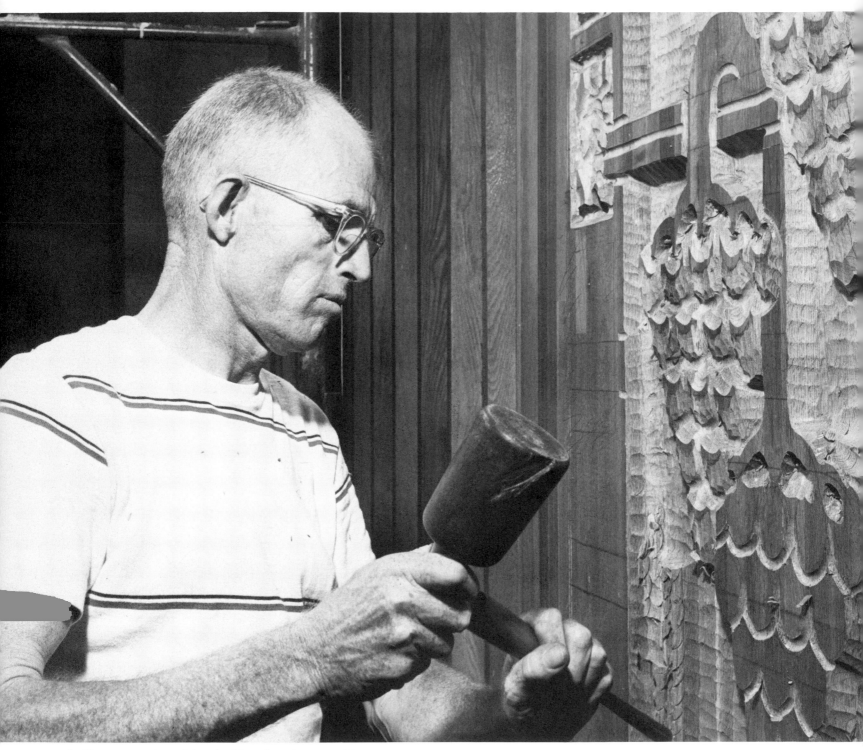

3. Flaten at work on *I Am the Vine*. Reredos carved in laminated white oak. Trinity Lutheran Church, Moorhead, Minn.

GOD AND WOOD AND ARNOLD Paul C. Johnson

My friendship with Arnold Flaten developed in what are usually called the "retirement years" for both of us. While we grew up in the same community and on the same St. Olaf College campus, he was just far enough ahead of me in school so we met only casually. Through the years, on my occasional visits to the campus, I watched the Flaten art department grow, and I became aware of Flaten sculpture appearing on each new building. His intriguing and charming individual pieces began to turn up in the homes of my friends. Most impressive of all, I encountered more and more Flaten carved altars and pulpits, sacristy panels, and arches in the churches I visited.

Lutheran churches, which had traditionally been content with stark paint, precise cabinet work and masonry, and rather indifferent altar paintings, were blossoming with rich carvings in oak and walnut, depicting the great themes of Holy Scripture.

I began to marvel at the quality and quantity of output from this man who certainly had a full time job teaching and directing an art department, but still found time for prodigious works of muscle, imagination, and spirit.

Then, quite suddenly it seems, I was back in Northfield where I sought out Arnold, to find him even busier after retirement, making the chips fly in the basement workshop of his home on Heath Creek on the edge of town.

Wood I have always loved—its aroma, its texture, its wayward grain, its amazing versatility as a God-given material for the uses and purposes of mankind. Here was a man whose love of wood was even greater than mine, and who had found ways of working with it that far transcended my own efforts with saw, straight-edge, plane, and turning lathe.

In one of our conversations Arnold dropped the remark that one of the best woods for sculpture is pearwood, and that it is very hard to find good pearwood in this northern climate. Pear trees do not grow big and solid enough in Minnesota. I remembered pear orchards I had seen in southern Illinois and Indiana. I dispatched letters to my farmer friends down in the Wabash country, asking them to be on the lookout for solid pear trees in the paths of bulldozers.

So I became a Flaten woodseeker, but not alone. I was only one of at least a dozen such persons on the lookout for interesting and workable woods for Arnold, a search which covers much of the globe. We bring home auto trunkfuls and leave the wood on the Flaten doorstep, determined that there shall be no dirth of raw material for the persistent chisel and the far-reaching imagination.

Arnold Wangensten Flaten was born May 18, 1900, in Northfield where his father Nils was a teacher of Romance languages and one of that group of great teachers who built St. Olaf College almost from scratch. His father and his mother, Inez Olsen, were both of Norwegian stock. One wonders if there may have been some genetic carryover from the Viking artisans of old who also loved wood and used it almost exclusively to build their homes, churches, and ships, always profusely carved and decorated.

Arnold grew up in a home dedicated to education, and especially to education in the humanities. While his love for art and considerable talent with pen and brush were strongly present in his high school and college years,

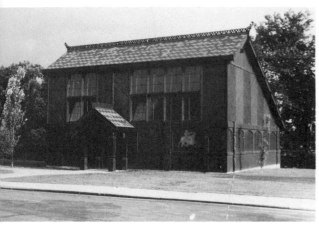

4. "Art Barn." St. Olaf College.

5. Flaten teaching.

these did not seem at the time to add up to a chosen profession. After graduation from St. Olaf in 1922, he set his course for Luther Seminary in St. Paul and a career in the church. He finished the seminary in 1925, was ordained, and was called as pastor by a small congregation in Laurel, Montana. It was here he learned to love western mountains and western people. This attachment in later years motivated him to build a summer home in the mountains near Red Lodge, Montana, just on the edge of Yellowstone Park. Many of his best works, of native mountain cedar, were conceived and executed here.

In 1928 Arnold left his western congregation to become associate pastor of Central Lutheran in Minneapolis, the largest metropolitan congregation of his church.

Lars W. Boe, president of St. Olaf, had kept an eye on the young pastor who was educated for the ministry but also imbued with rare artistic talent. He asked Flaten if he would go abroad to study art for a number of years and return to establish an art department at his alma mater. St. Olaf had a worldwide reputation for its music, along with other educational accomplishments, but up to that time an art department had been considered a luxury.

The early thirties was no time to spend money on something new and frivolous in a struggling church college, but Boe had his mind made up. Somehow the money got scratched together. Arnold went off to study in Florence and Paris for two years. Evelyn Solberg, his sweetheart, joined him there and they were married. Together the young couple braved the chancy life of the art student in the midst of worldwide depression.

They returned to St. Olaf in 1932. A wooden shack was built on the rim of Norway Valley to house the new department. This shack was like nothing you had ever seen. It was done entirely of wood in the best old Norse tradition—with Viking symbols and carvings all over the front. For Arnold was not only founding an art department; he was beginning a life-long love affair with wood sculpture, and his young wife was growing accustomed to sawdust in the soup and wood chips in the bed.

Today there is a new art building at St. Olaf named Flaten Hall. It is of stone and glass, appended to the wooden shack where it all began. Arnold Flaten directed the department for nearly forty years, steering it through a period of much uncertainty and experimentation in the art world. His students have not only done well in personal and professional art; they have carried what they learned about art, its history, and its place in the total aspirations of man, into other vocations and professions to enrich their life and their work.

After retirement—if you can call it that—Arnold has increased his output of sculptures in wood, carrying out commissions for churches and other clients, and creating many free-standing pieces which have appeared in one-man shows. He has had exciting assignments as guest sculptor at California Lutheran College in 1971-72, and as resident artist and lecturer at the Tri-College Humanities Forum in Moorhead, Minnesota, in 1973-74. Whether he is at home, at his mountain retreat in the West, or on appointment at an educational institution, the chips continue to fly. He cannot escape the creative urge.

I respect Arnold Flaten for his devotion to the Scriptures and to the God they celebrate. The characters and themes of the Bible are his favorite idea

6. Baptismal font. Kasota stone. Zion Lutheran Church, Dysart, Iowa.

material, although he does not hesitate to use other great literature and even contemporary affairs as his source material.

God and wood and Arnold emerge as a kind of working trinity as you study the sculptor's works. What could be more fitting in an artist who has deep feeling for all things organic and human as they relate to the divine!

Wood is one of the greatest gifts of God to man. It is the product of a lifetime of exposure to sunlight, rain, wind, and natural hazards—what we ordinarily refer to as "acts of God." This experience is incorporated into the very form and grain and texture of the wood before it submits to the will and the imagination of the sculptor.

Arnold works by what he calls the "direct cutting" method, meaning that he often improvises and even changes direction as the work progresses. The original wood has its own will, as it were, which sometimes prevails over the ideas of the sensitive sculptor who goes along with that will. The material makes its own contribution of beauty and direction. Deeply involved in this partnership of man and wood is a consciousness of the will of God for man, as well as the generations of tension, struggle, and achievement that make up the history of man.

What comes out is what you see in this book.

There is no room in this creative process for the cult of contrived "meaninglessness" which has so often been enthroned in the art world in recent years.

I like Arnold's work also because it is just that, work. I hold in greatest respect those creations of art that unquestionably required painstaking care, skills of eye and hand, blood and sweat, along with the tears and the ecstasy.

On examining the panels and altars carved by Arnold for the churches and for buildings on the St. Olaf campus, I am amazed at the physical effort which they must have cost. Obviously, the arm that wields the mallet, and the hand that guides the chisel and gouge have sinews of steel.

I keep thinking of Michelangelo, lying on his back on a high scaffold painting the ceiling of the Sistine Chapel, or carrying out other great assignments that took months and years. Along with the exercise of divine talent, there was required vast amounts of work and management, searching for an assembling material of proper quality, solving engineering problems of large scale creation, directing assistants—working, working, working.

As a writer and editor, I also appreciate Flaten's liberal use of the printed word—in his case the sculptured word. The Word as it comes down to us in the Bible, as well as the best thoughts of man through the ages, has been communicated by the alphabet.

I can understand the art world preferring other forms of communication, but I find it hard to forgive my own profession of journalism for denigrating the word in favor of the cult of photography. I want to cry out in protest against the old cliché that a picture is worth a thousand words and declare instead that the right word is worth a thousand pictures.

My gratitude for the excellent photography that made possible this book must be expressed here. Nevertheless, I salute Arnold Flaten for using words freely in so many of his sculptures and carvings. They belong. They speak eloquently of the sculptor's profound respect for the scriptures of both God and man and the wisdom of the ages. Disregard of those messages can lead only to poverty of mind and spirit.

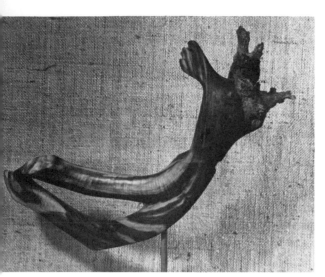

7. *O Frabjous Day!*. Cedar.

After I learned to know Arnold better personally as well as through his works, I discovered other characteristics that increased my appreciation.

In spite of what may be regarded as very orthodox theological training and environment, he is anything but rigid in his outlook. The only orthodoxy in him is his high regard for good work and the inheritance from the past. He doesn't like to be called an artist. He prefers to call what he does his work, and he rejects the notion that artists are a group apart. He urges me to strike out on my own and express my ideas in wood, disregarding the blueprint and the carpenter's square. I find it hard to accept his premise that every man can be his own do-it-yourself artist if he will but overcome his fear of failure and ridicule. But I am so charmed by his confidence in me that one of these days I may try out his theory.

In some respects Arnold is a dissenter in both his fields, theology and art. The thundering themes of the Bible and its characters, weak as well as strong, are ever present in his work. But he is also a great admirer of William Blake, English poet, engraver, painter, and free-wheeling theologian of the early nineteenth century.

While Arnold Flaten's interests have reached into many branches of art, his most notable teaching and writing has been in the history of art and the close kinship of art and architecture. He has waged war on the hodgepodge marriages of art and architecture that turn up in our churches and public buildings. It is in his nature to protest and then to do what he can to ameliorate such mistakes. For a man who is unhappy about much of the architecture of our churches, he has done much to make them suitable places of worship.

Arnold comes through to me as essentially a gentle soul, though fully capable of outspoken indignation. He can't stay angry at anybody or anything for very long. His works reveal this need to love people, and his warm appreciation of their strivings and tensions. There is room for gentle irony, for a "more in sorrow than in anger" approach to the meanness that turns up in us and our institutions. This is utterly refreshing in a world that has been too much obsessed lately with feelings of collective guilt, expressions of hopelessness, and calls for complete withdrawal.

His gentle irony is superbly expressed in such pieces as "The Esthetic Snob" and "Paternalism." In contrast there are also bursts of pure joy and love of life, such as a piece in western cedar which my wife fell in love with and which graces our living room. There is nothing ponderous, Lord knows, about "O Frabjous Day, Callooh Callay" from Lewis Carroll's Alice. Arnold has a keen appreciation of "found art." Often as in this piece of cedar, the tree did most of the work and the sculptor provided only a pedestal and a little extra push in a direction already indicated.

It has been said that one of the most important lessons a teacher can learn is that "you must first learn to love man before you set out to improve him." That Arnold has followed this principle is shown clearly in his sculpture as well as in the high esteem his students hold for him.

This book is your opportunity to study his work, to enjoy, to linger. The sculptor says it was fun producing it. You'll find a wide range of human emotion and aspiration, and a gentleness that will help you cope with a troubled world.

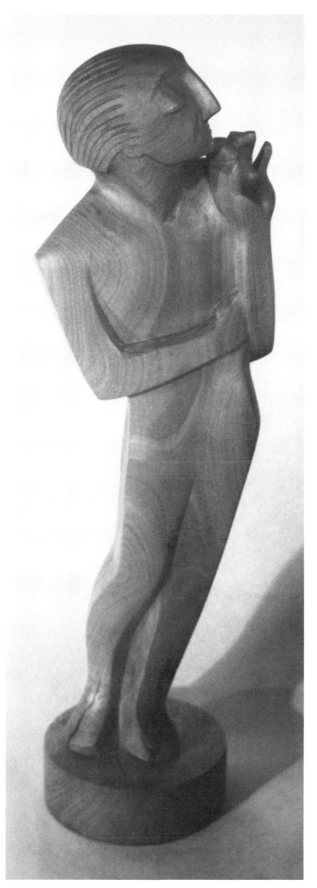

8. *The Esthetic Snob*. Pear.

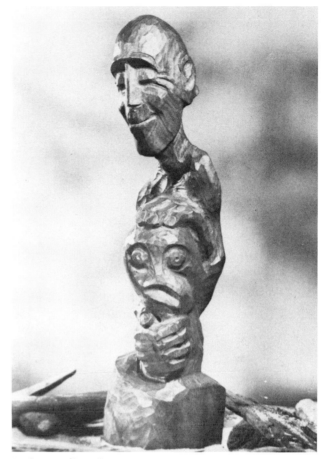

9. *Paternalism*. Butternut.

13

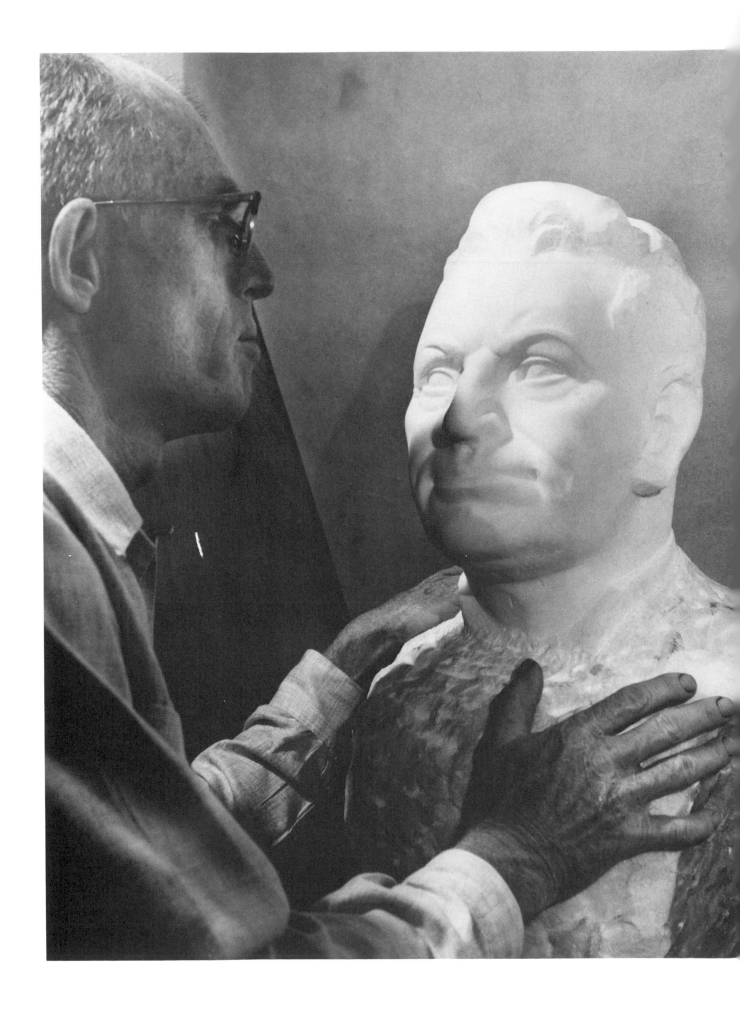

GRACE IS THE IMPORTANT WORD

Arnold Flaten

One who leafs through the pages of this book will discover several things. One is that the sculptor's favorite material is wood. There are a few marble and kasota stone pieces and one portrait in bronze. I certainly do not minimize the sculptural quality of these materials. However, wood seems to suit my temperament and the intent of my work. Wood is a friendly material and, like watercolor, finds its best use in smaller, more intimate sculptures.

Many of my carvings are in the living rooms of friends. Wood lacks the monumentality of stone. It should be viewed at close range and even picked up and handled. It has many qualities with eye and touch appeal. Even the sense of smell is involved. Camphor wood, cedar, myrtlewood, and sandlewood fill my shop with fragrance.

The world's supply of woods contains an amazing variety of texture, color, grain, density. Compare the silky texture of pearwood with the coarser, more porous butternut; the strongly marked reddish cedar with the deep rich brown of walnut; the density and hardness of ebony with Minnesota white pine.

The great variety of woods has intrigued a group of individuals called wood collectors. They are similar to rock hounds, only more rare. Their common bond is a great love for wood and the ambition to accumulate a large number of specimens. Several years ago I discovered a genuine wood collector who is a neighbor and former student, Fran Hall. From him I have learned much about wood, and his generosity has added to my stockpile. Through the years this stockpile has grown as friends and former students have brought wood from nearly every part of the globe: monkey pod from Hawaii, rosewood from Madagascar, kamagong from the Philippines, ebony from Tanzania, camwood from Nigeria, Ironwood from Arizona, pearwood from Indiana, teak from southeast Asia, caragana from Brazil, myrtlewood burl from Oregon, camphorwood from Taiwan, and many more.

While studying in Paris, I occasionally noticed a wood sculpture in an art exhibition with the label "direct cutting." This means that the sculptor had gone directly to the block of wood without preliminary models in clay or wax. He was not transposing his model to the wood. He was making decisions while the mallet and gouge were making the chips fly.

Of course this is risky. A mistaken decision is difficult to correct. Why take the risk? I find the value of this procedure far outweighs the hazards. One's mind is kept alert and open to new possibilities; and there is a much better chance that one will respect the medium and that the finished product will retain its wood quality. "Direct cutting" helps the sculptor to listen to voices which at times lie outside of conscious rational thought. Serendipity.

The sculptor deals with three-dimensional images. He is not a musician. To move sculpture toward music denies the essential character of the medium. At its best sculpture is a kind of incarnation of the spirit. The Word became flesh and dwelt among us. Like visible nature, it seeks to embody in its form some thought which lies beyond its image. It contains a symbolic projection. The sculptor charges the image with some of his own spirit. Images are the sculptor's language.

"In wildness is the preservation of the world." Our age is becoming increasingly aware of Thoreau's perception as he made this statement. Visual

10. Sculptor with
F. Melius Christiansen.
Marble.

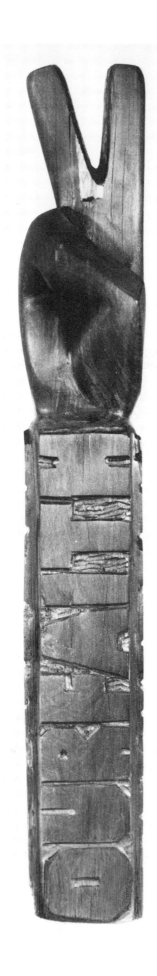

nature is a great inspiration and teacher for those who learn gradually to understand her language. Architect Frank Lloyd Wright called nature his great teacher. She is an inexhaustible source book of design and inspiration. But, like past historical cultures, she is not for imitation. A sculptor does not show his appreciation of nature by copying her forms. I disagreed with my French sculpture teacher who kept repeating, "Remember, nature is always stronger than you are."

That is not the point. Nature is for inspiration, not imitation.

No man of sense ever supposed that copying from nature is the art of painting; if art is no more than this, it is no better than other manual labor; anybody can do it and the fool often will do it best as it is the work of no mind.
Blake

William Blake shares with Rembrandt a reputation for great productivity. One day several young artists called on Blake and asked him to tell them the source of his inspiration. He turned to his wife and said, "Katie, what do we do?" She replied, "We pray, Mr. Blake." No doubt this was true, but it is an oversimplification. Blake had a deep concern for man and his predicament. He felt the early impact of the industrial revolution and its harm to mankind. He became one of the most passionate fighters for man's integrity. In other words he was a person with something to say, an urgency to get his message across. He had no time for the renaissance concept of the artist as a special kind of person pursuing beauty. Quite the contrary, he thought every man is a special kind of artist. The problem of each individual is to find a way to affirm his intuitions of the truth. Blake had ideas and visions which he wanted to share. His art was an expression of an inner necessity.

I cite Blake because he has been most helpful to me. With him I reject the renaissance concept of the artist and find no durable challenge in a neo-platonic pursuit of beauty *per se*. The so-called age of meaninglessness has little significance to one with Blake's point of view. The world is full of a number of things that need to be said. Sculpture can participate in shaping the symbols for the present generation.

Early in my college teaching career I was asked if I taught modern art. I replied that I was teaching students who are living in the twentieth century.

This may sound a little evasive. Rephrasing the question one might ask if I taught what was current. I think it was Gertrude Stein who said that Picasso was contemporary before the contemporaries knew what was contemporary.

Until recently the art world has had an obsession for -isms. Gallery directors, museum curators, painters, and sculptors seemed to believe that the wave of the future was in their hands. Conformity to the "now"-ism was part of their game.

This is quite different from a sensitivity to the challenges and needs of the times. The sculptor who has something to say will not be bound by current fads. To try to conform to the current mode, to self-consciously worry about style reflects a feeling of insecurity. The only hope of being genuinely modern lies in trusting one's own intuitions of the truth.

I have made several carvings based on the burning bush symbolism. I shall not attempt an exegesis of this Old Testament theophany. The application I would like to point up is best expressed by the assertion of the Apostle

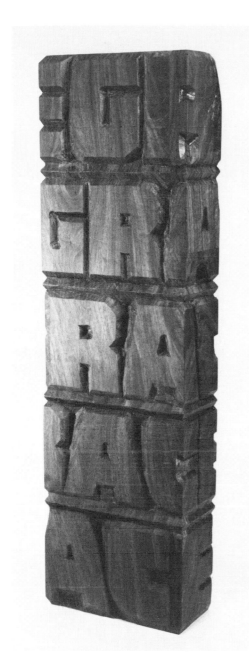

Paul who repeats the burning bush words, *I am what I am,* and then adds, *by God's grace.* This is self-affirmation combined with an acknowledgement of God's grace. There is an essay on art by the brilliant Chinese artist Shih-T'ao (1641-1717) that speaks to the importance of self-affirmation.

I am as I am; I exist. I cannot stick the whiskers of the ancients on my face I prefer to twitch my own whiskers Why should I model myself upon the ancients and not develop my own forte?

By assuming the burden of selfhood one develops the confidence to trust the inner voice. One's sculpture becomes what Blake calls *emanations.* Sculpture becomes an extension of the self and a personal witness. *Grace* is the important word.

Following a lecture at an international student camp on the subject of architecture one of the students asked me, "How do you know you are right?"

It was a valid question and a difficult one to answer. Blake's answer would have been, "He who does not know truth at sight is unworthy of her notice."

This is a risky position. There is always the possibility of being wrong. All the same, I see no viable alternative except the additional grace to recognize and admit error.

My awareness of grace has increased during the years. It does not follow necessarily that my sculpture production has bettered. All I can say is that my work has been fun. As I learn to take myself less seriously, the sculptural ideas keep piling up. Given a stockpile of wood and some sharp gouges, I greet the morning with a feeling of eagerness. I want to get to my bench, to that piece of Arizona ironwood I put in the vise yesterday.

Forgetting what is behind me, and reaching out for what lies ahead, I press towards the goal to win the prize which is God's call to life above, in Jesus Christ.

Phil. 3:13-14.

12. *Grace.* Walnut.

11. Opposite page: *Victory.* Rosewood.

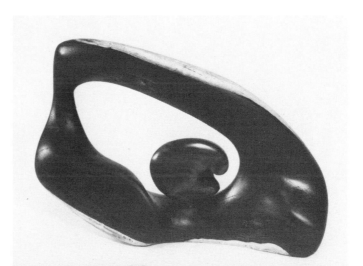

13. *Seed in Ground.* Arizona ironwood.

17

14. *Sculptor.* Cedar

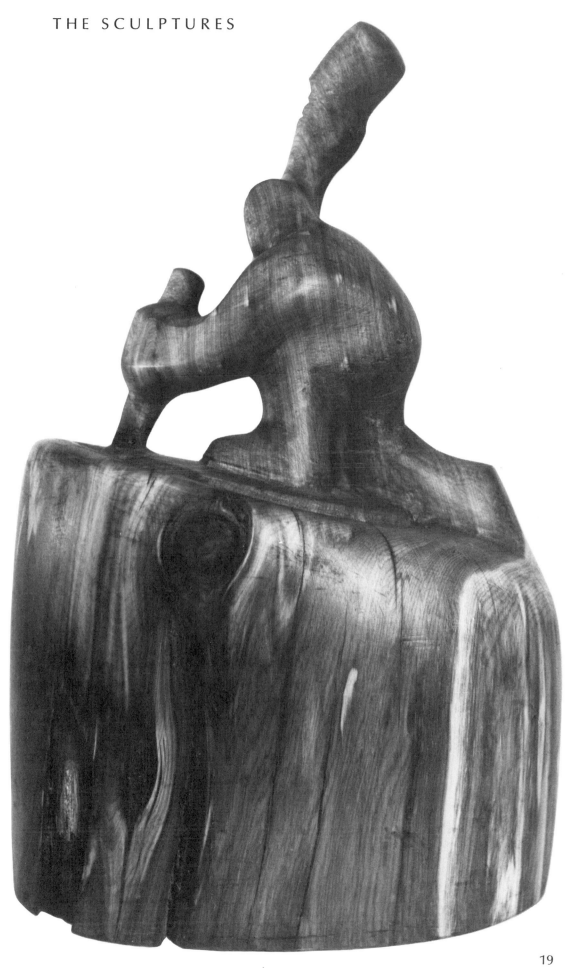

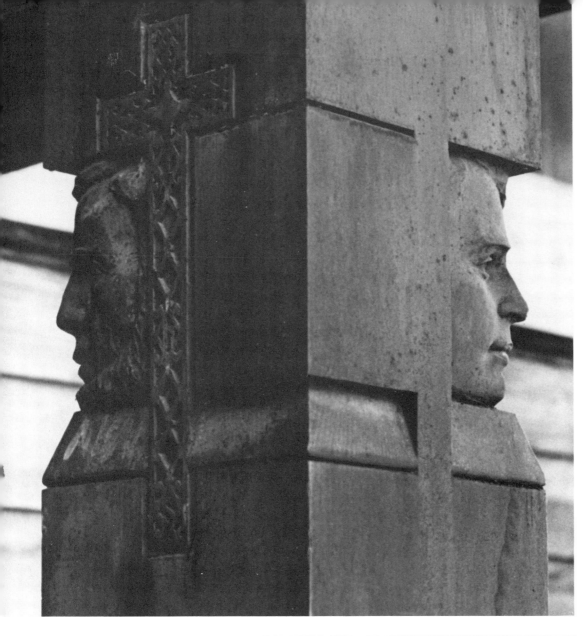

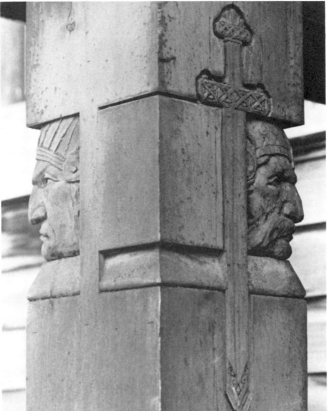

15. *Norwegian Immigrant, Student, Indian and Viking Heads.* Wooden posts on "Art Barn," St. Olaf College, Northfield, Minn.

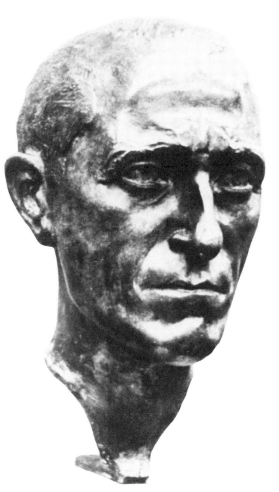

16. *C. A. Mellby.* Bronze.

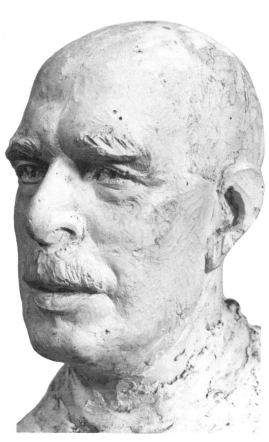

17. *Eric Hetle.* Plaster.

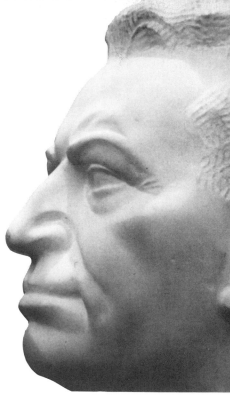

18. *F. Melius Christiansen.*
Marble.

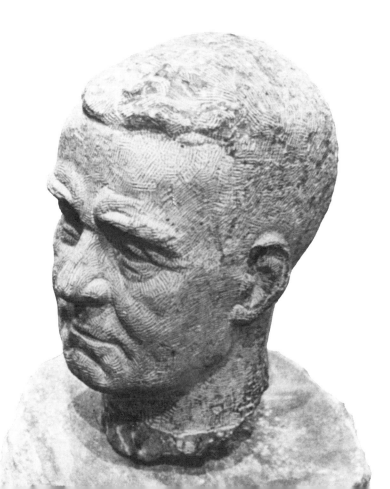

19. *Nils Flaten.*
Faribault limestone.

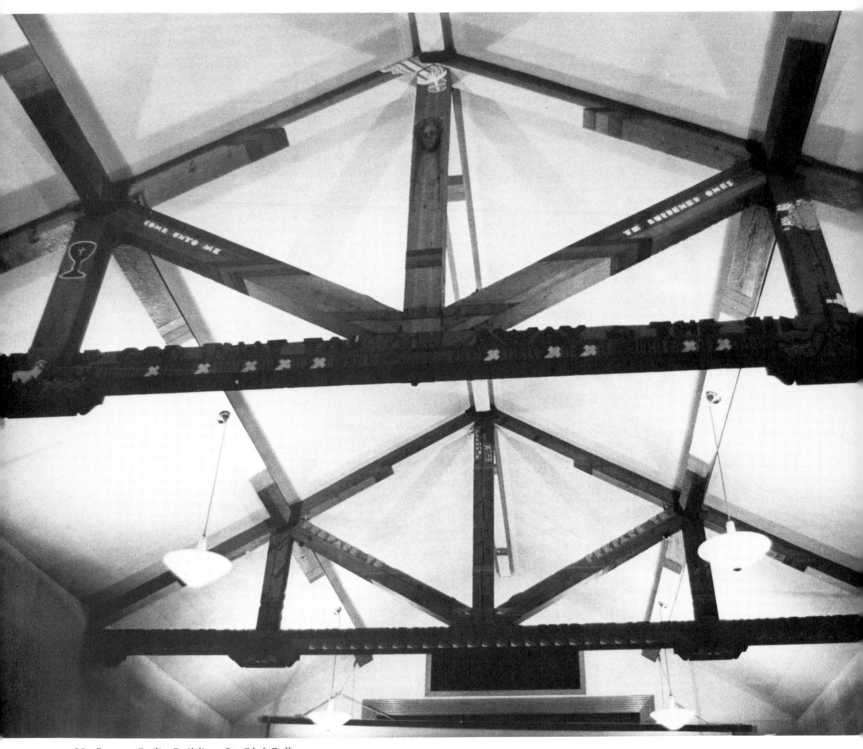

20. Beams. Radio Building, St. Olaf College.

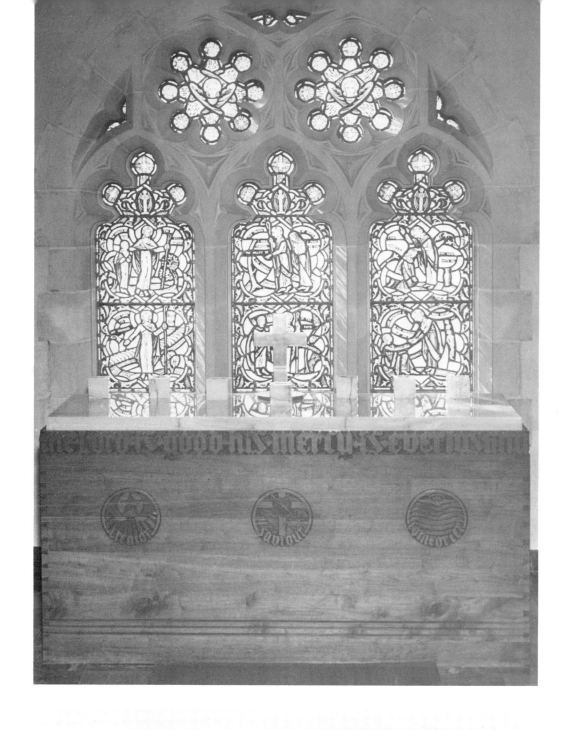

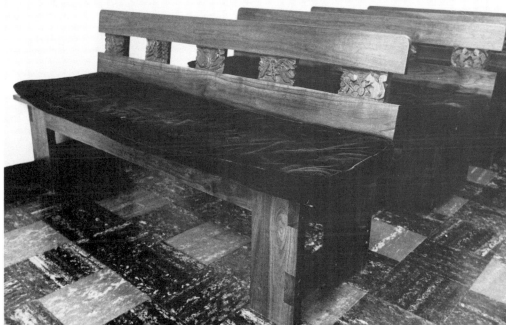

21. Altar and pews. Chapel at Agnes Mellby Hall,
St. Olaf College.

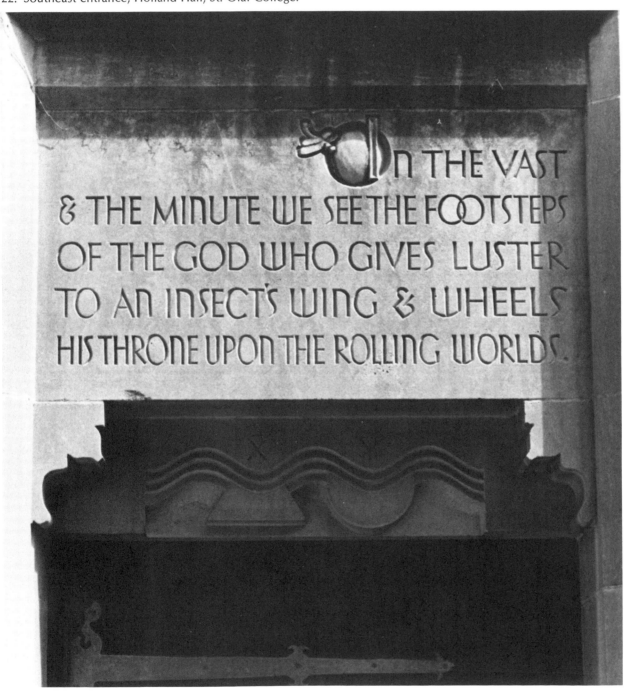

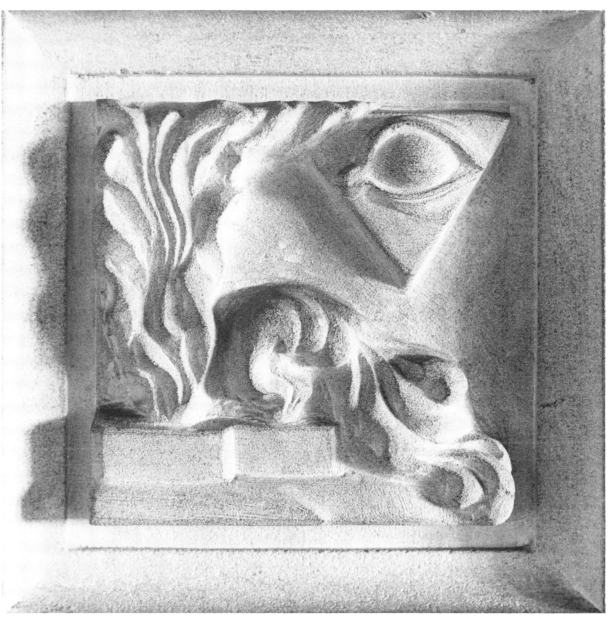

23. Fireplace mantel details, Hauge room of Rolvaag Library, St. Olaf College. Above: *Cain and Abel Sacrifice.* Left: *Burning Bush.*

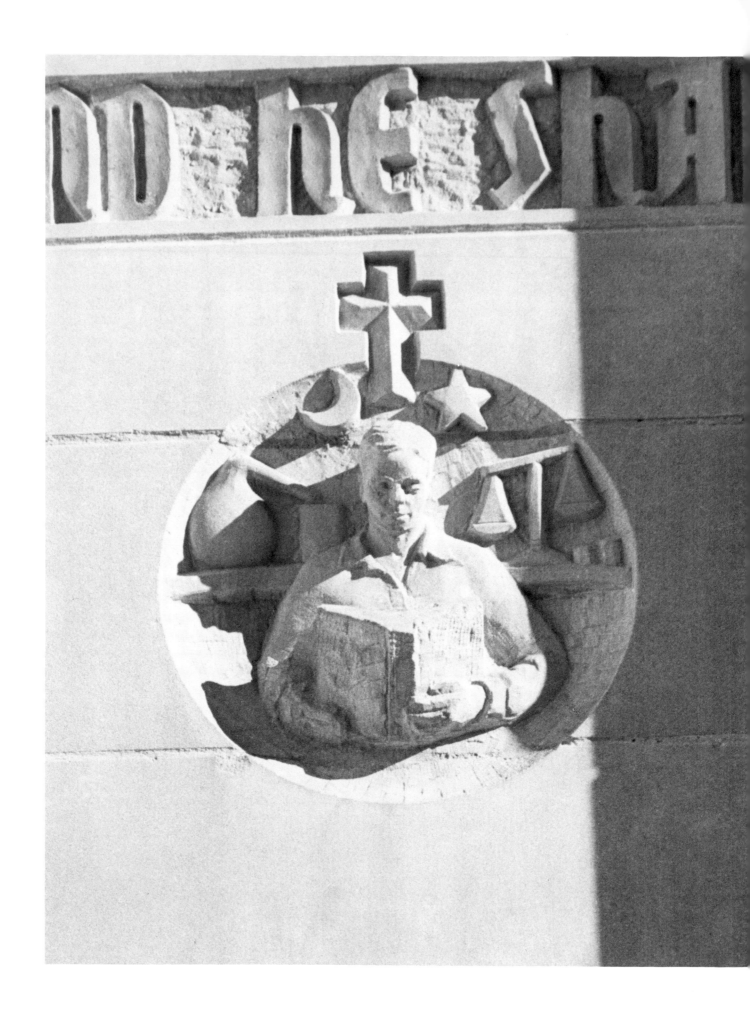

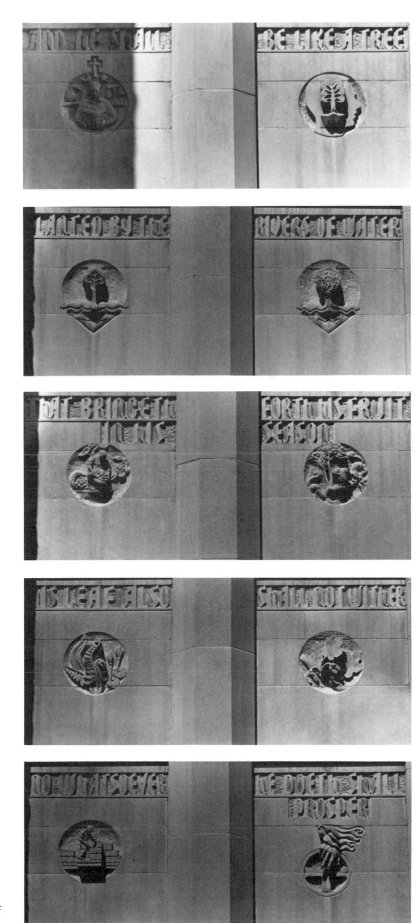

24. South spandrels of Rolvaag Library, with detail of first carving from the text of Psalm 1.

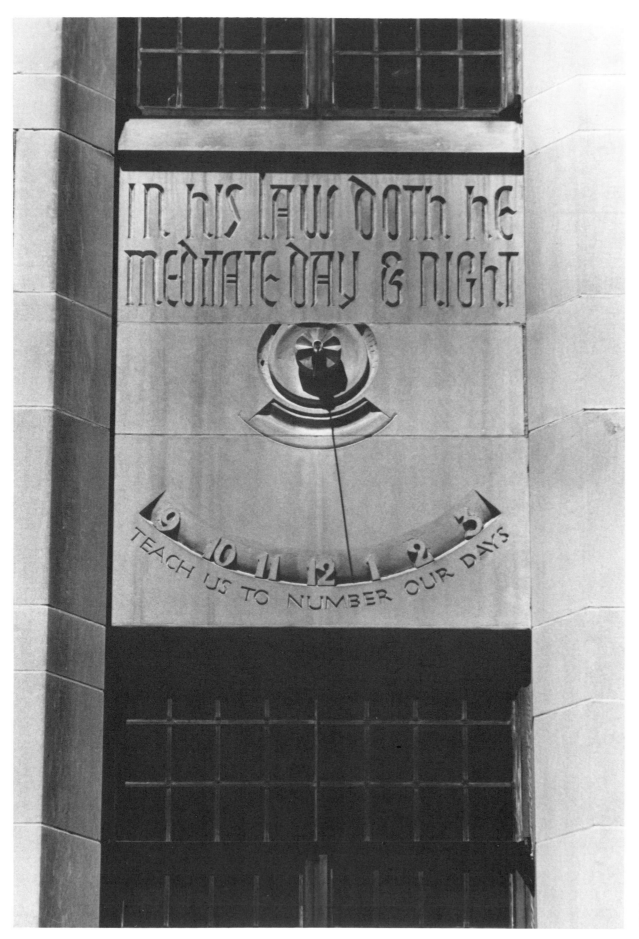

25. Sundial. Above doorway, Rolvaag Library.

26. Northeast entrance, Holland Hall, St. Olaf College.

27. Southwest entrance, Holland Hall, St. Olaf College.

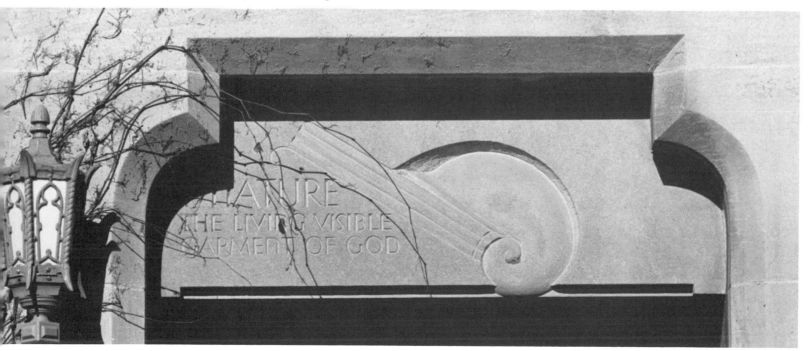

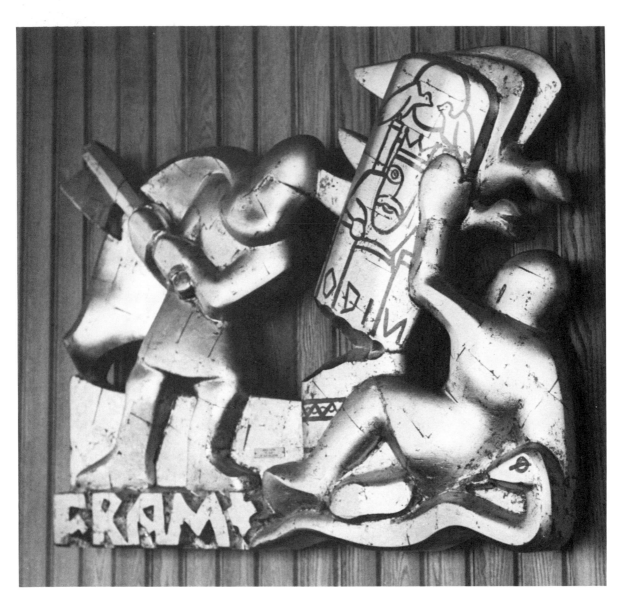

28. *King Olav.* Kings Room "Center," St. Olaf College.
Below left: *Leif Ericcson.* Kings Room.
Below right: *Haakon Jarl Sigurdson.* Kings Room.

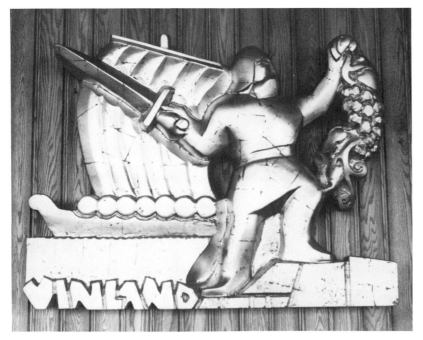

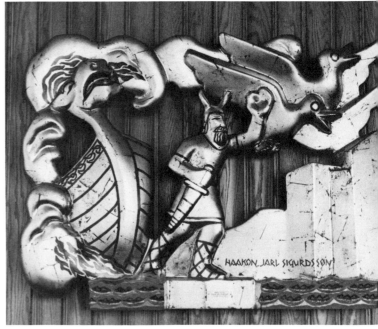

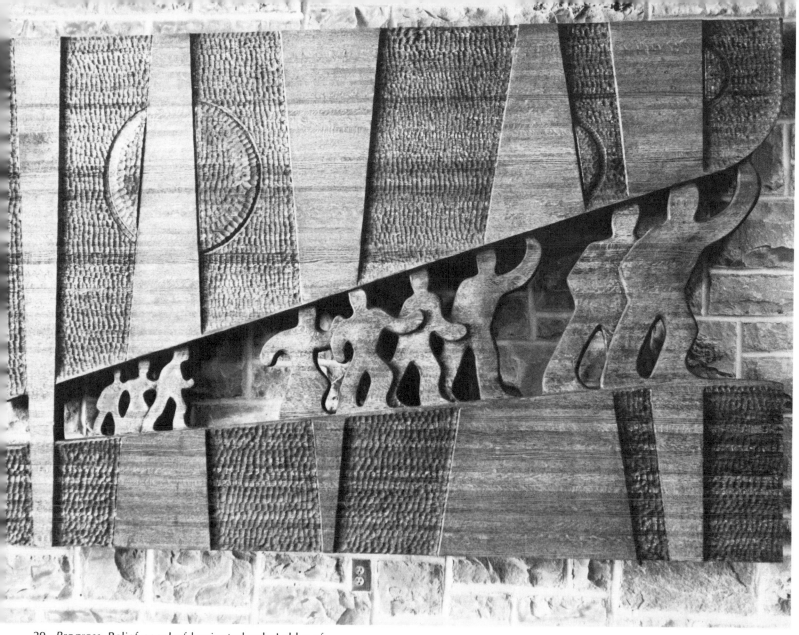

29. *Progress*. Relief panel of laminated oak. Lobby of
Science Center, St. Olaf College.

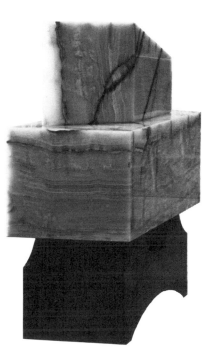

30. Rhomboid and cube with laminated
oak base. Mexican onyx. Lobby of Science
Center, St. Olaf College.

31. Flaten Hall, north view. St. Olaf College.

32. Flaten Hall, south view. St. Olaf College.

32

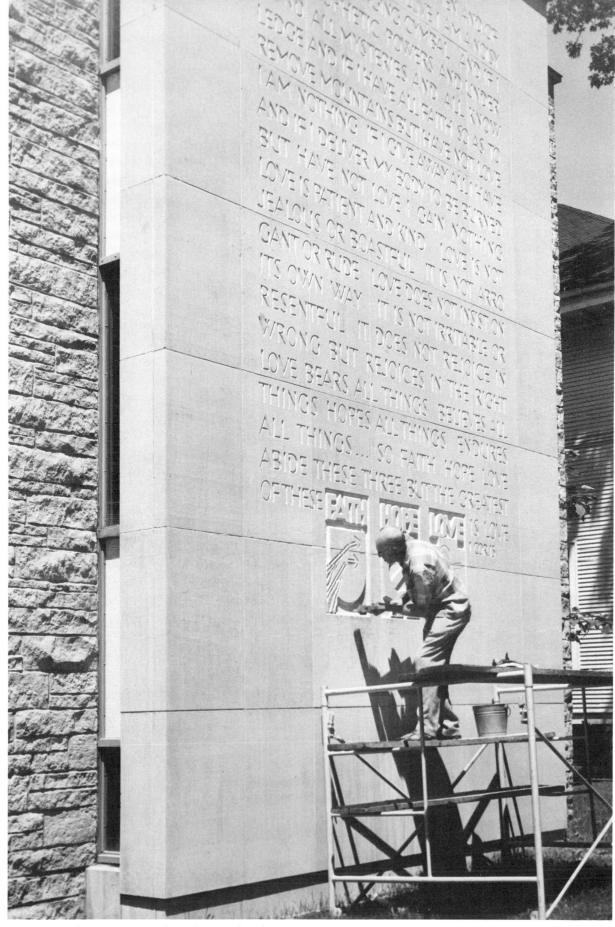

33. *1 Corinthians 13*. St. Paul's Lutheran Church, La Crosse, Wis.

IF I SPEAK IN THE TONGUES OF MEN AND OF
ANGELS BUT HAVE NOT LOVE I AM A NOISY
GONG OR A CLANGING CYMBAL AND IF I
HAVE PROPHETIC POWERS AND UNDER
STAND ALL MYSTERIES AND ALL KNOW
LEDGE AND IF I HAVE ALL FAITH SO AS TO
REMOVE MOUNTAINS BUT HAVE NOT LOVE
I AM NOTHING IF I GIVE AWAY ALL I HAVE
AND IF I DELIVER MY BODY TO BE BURNED
BUT HAVE NOT LOVE I GAIN NOTHING
LOVE IS PATIENT AND KIND LOVE IS NOT
JEALOUS OR BOASTFUL IT IS NOT ARRO
GANT OR RUDE LOVE DOES NOT INSIST ON
ITS OWN WAY IT IS NOT IRRITABLE OR
RESENTFUL IT DOES NOT REJOICE IN
WRONG BUT REJOICES IN THE RIGHT
LOVE BEARS ALL THINGS BELIEVES ALL
THINGS HOPES ALL THINGS ENDURES
ALL THINGS ... SO FAITH HOPE LOVE
ABIDE THESE THREE BUT THE GREATEST
OF THESE **FAITH HOPE LOVE** IS LOVE
1 COR. 13

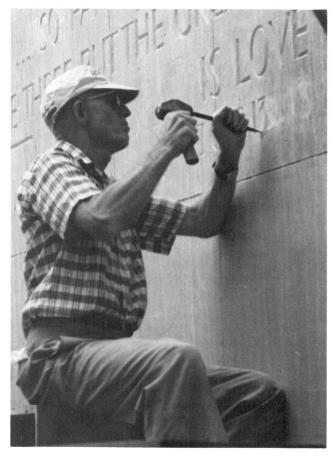

34. Two views of *1 Corinthians 13*. St. Paul's Lutheran
Church, La Crosse, Wis.

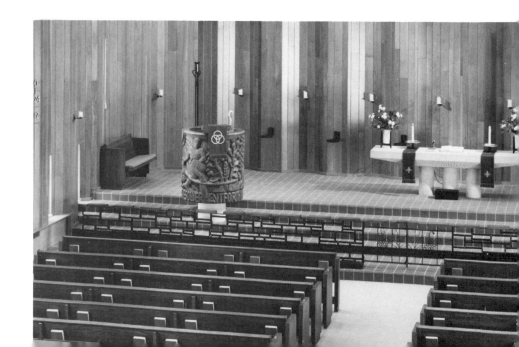

34

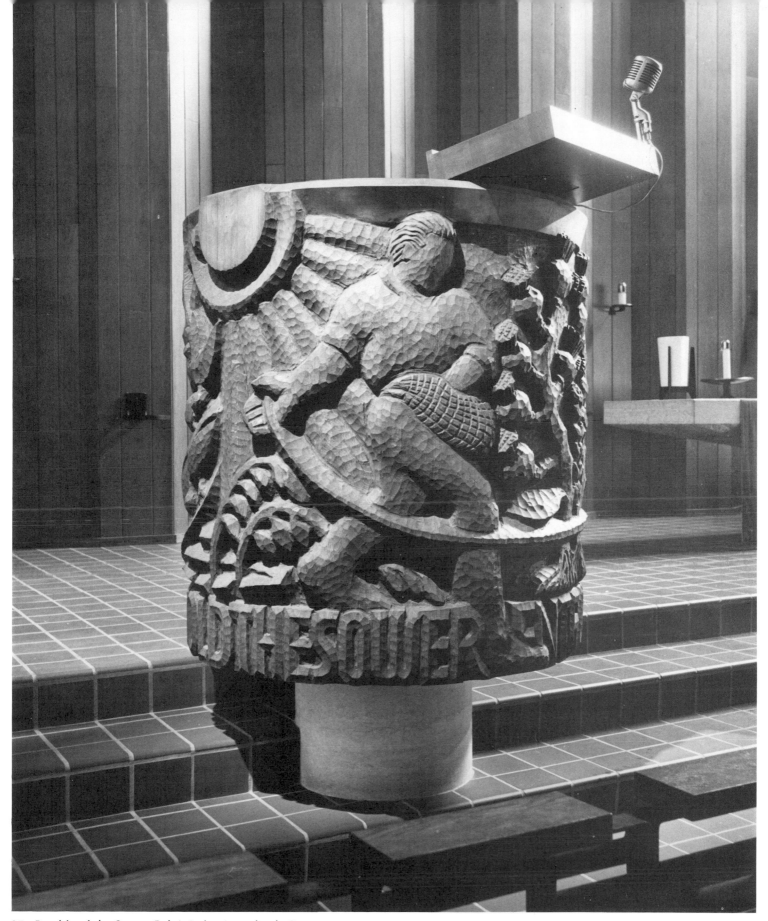

35. *Parable of the Sower*. Pulpit in laminated oak. St.
Paul's Lutheran Church, La Crosse, Wis.
Opposite page: view of pulpit in St. Paul's chancel.

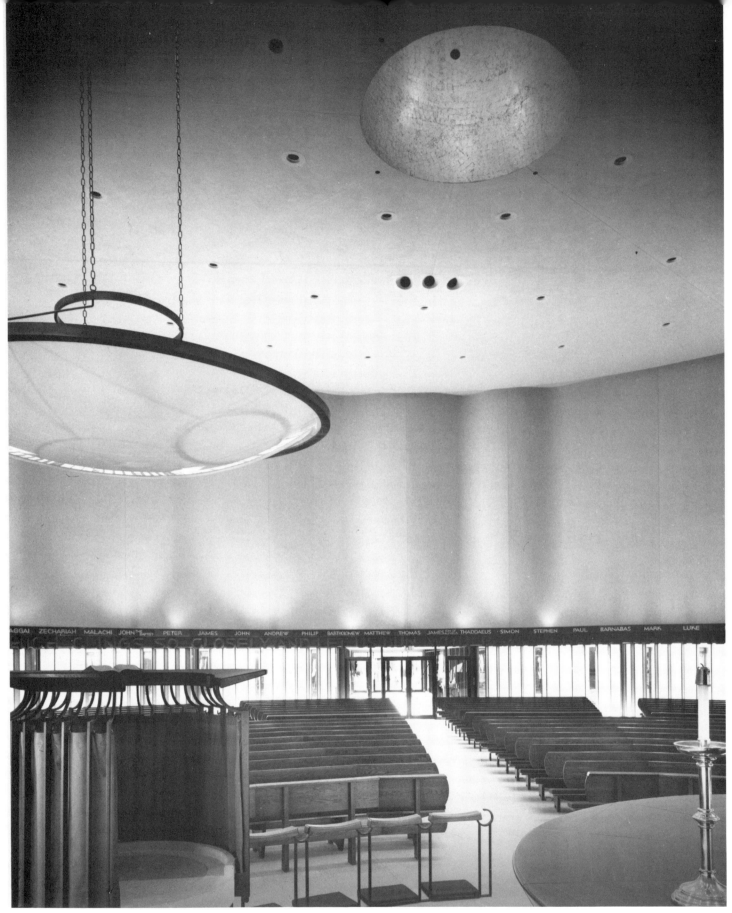

36. *A Cloud of Witnesses*. Oak carvings and gold leaf.
Circular interior of Vinje Lutheran Church, Willmar, Minn.

37. Four Advent panels. Laminated oa
Chancel, Vinje Lutheran Churc

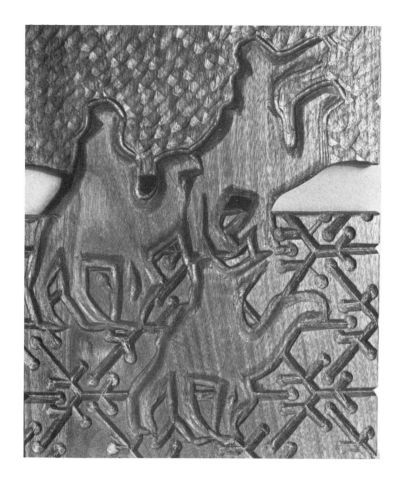

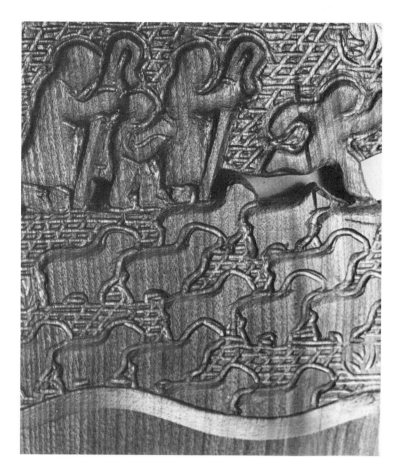

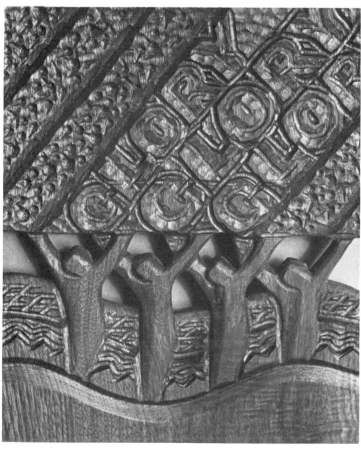

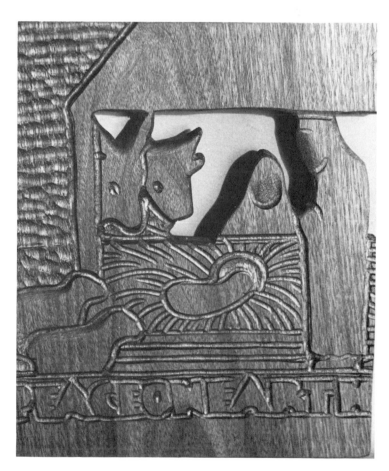

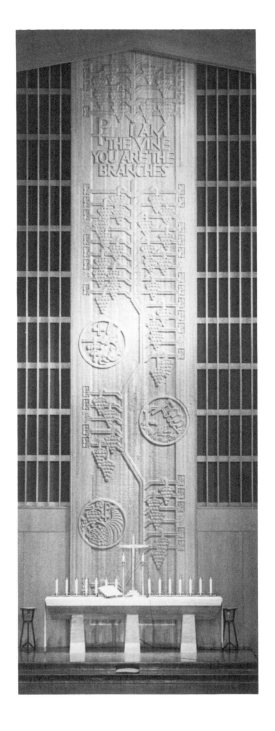

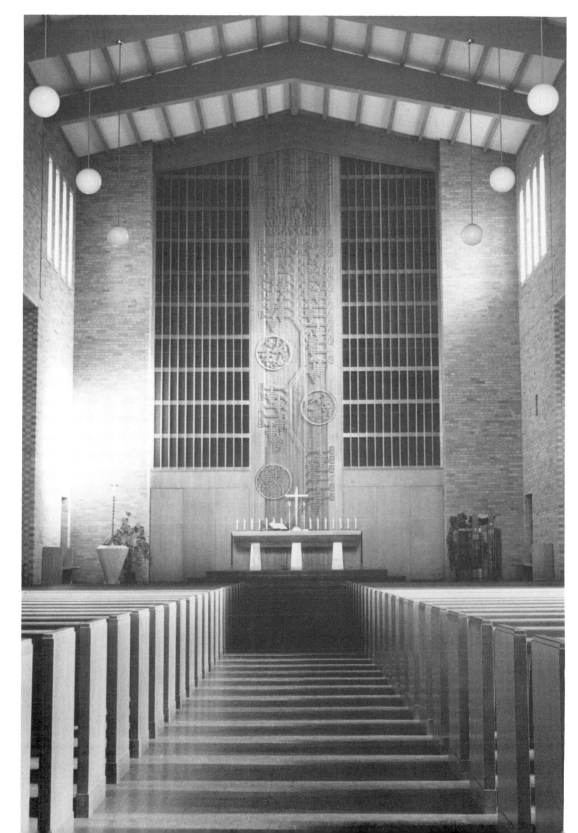

38. Views of reredos, *I Am the Vine*. Trinity Lutheran Church, Moorhead, Minn.

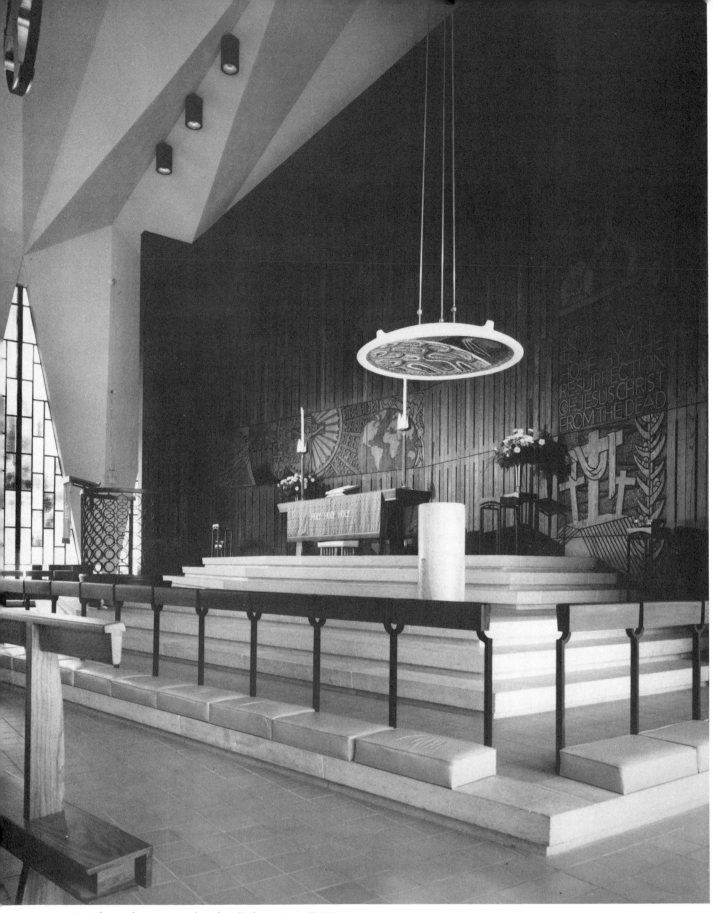

39. Chancel screen with oak relief carvings. Trinity
Lutheran Church. Minnehaha Falls, Minneapolis, Minn.

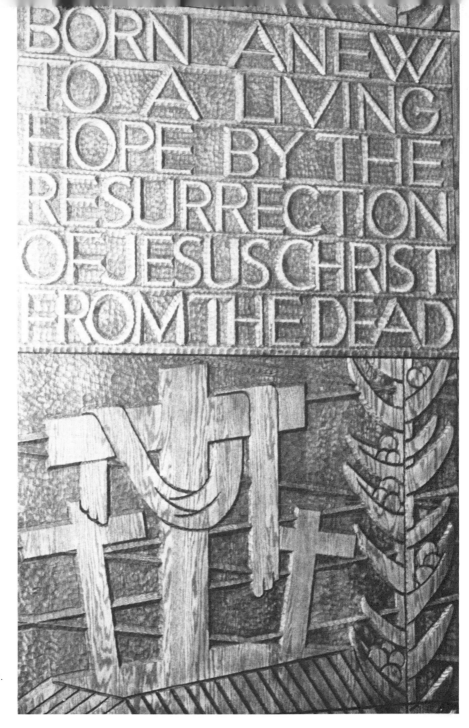

BORN ANEW
TO A LIVING
HOPE BY THE
RESURRECTION
OF JESUS CHRIST
FROM THE DEAD

40. Details of chancel reliefs. Right: *Resurrection*.
Below: *Redemption*. Trinity Lutheran Church,
Minnehaha Falls.

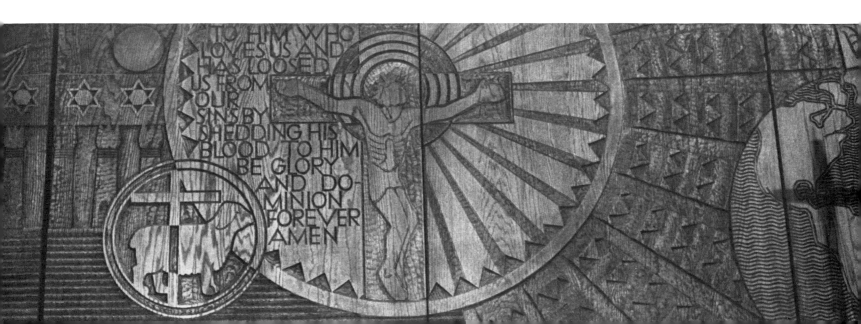

TO HIM WHO
LOVES US AND
HAS LOOSED
US FROM
OUR
SINS BY
SHEDDING HIS
BLOOD TO HIM
BE GLORY
AND DO-
MINION
FOREVER
AMEN

41. *Twenty-Third Psalm.* Three walnut panels in lobby of
Jackson Municipal Hospital, Jackson, Minn.

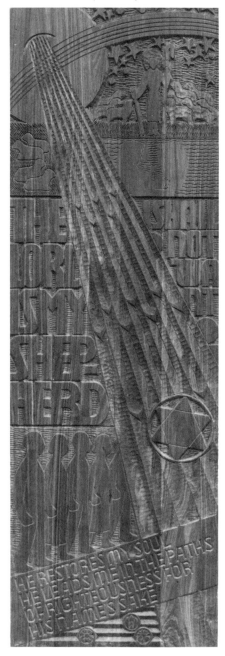
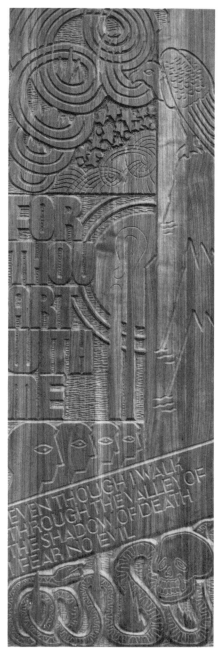
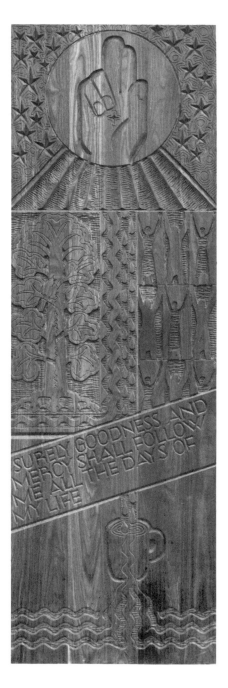

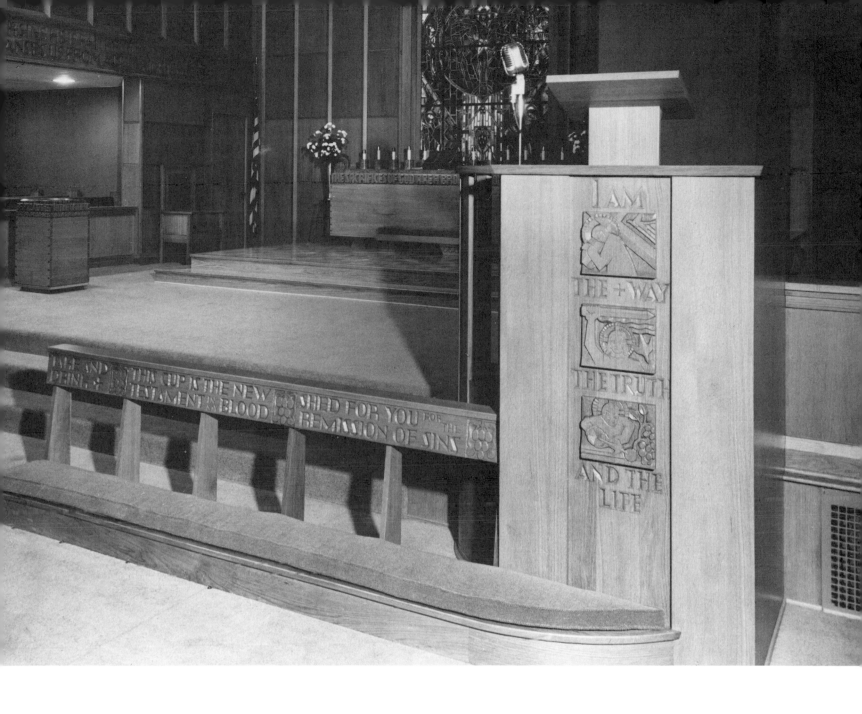

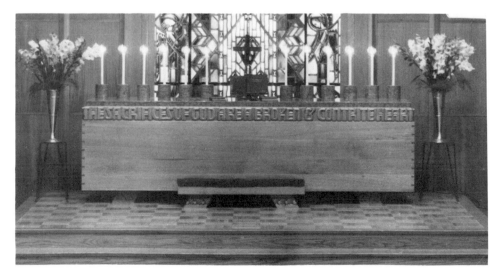

42. Above: Lettering in chancel area. First Lutheran Church, Eau Claire, Wis. Right: Altar. Oak. First Lutheran Church, Eau Claire, Wis.

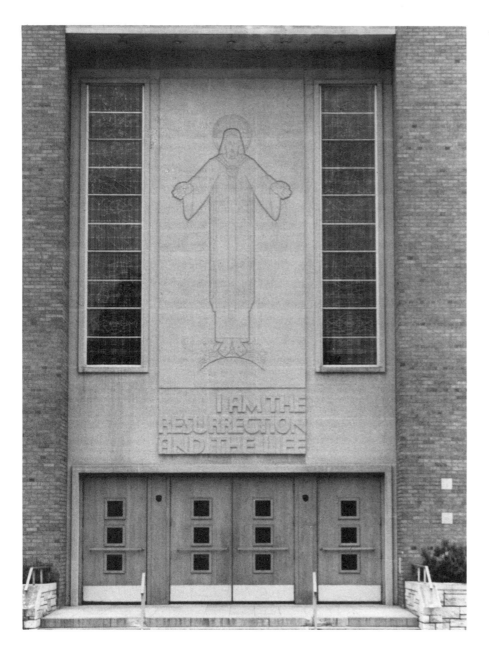

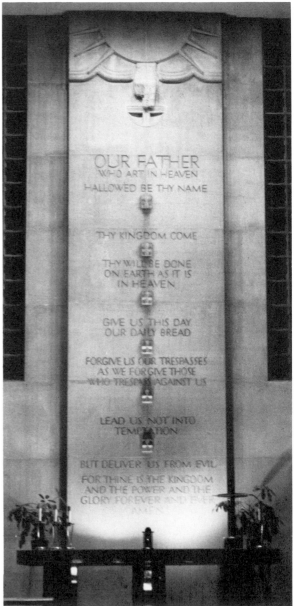

43. Resurrection symbol above main entrance.
Kasota stone. First Lutheran Church, Duluth, Minn.

44. *The Lord's Prayer.* Reredos of Kasota stone.
First Lutheran Church, Duluth, Minn.

BLESSED ⳨ ARE THE PURE IN HEART FOR THEY SHALL SEE GOD ◆ ◆ ◆

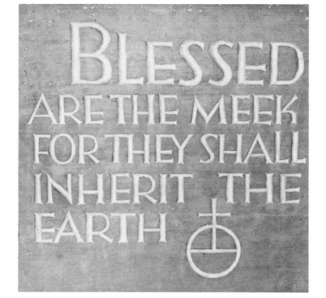

BLESSED ARE THE MEEK FOR THEY SHALL INHERIT THE EARTH ☨

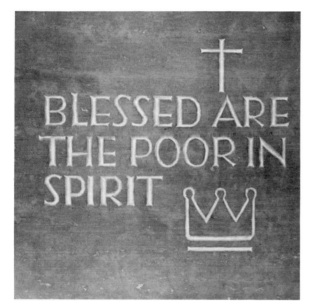

BLESSED ARE THE POOR IN SPIRIT

BLESSED ARE THE PEACE-MAKERS

A BLESSED ARE THE MERCIFUL FOR THEY SHALL OBTAIN MERCY

BLESSED ARE THOSE WHO HUNGER AND THIRST FOR RIGHT-EOUSNESS

45. *The Beatitudes.* Kasota stone. Nave sidewall inserts, First Lutheran Church, Duluth, Minn.

46. Trinity Lutheran Church, Hoveland, Minn.
Below: Altar at Trinity Lutheran Church.

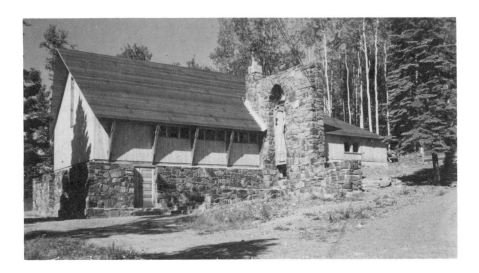

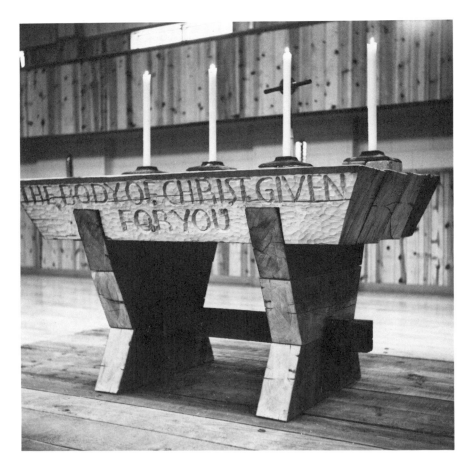

47. Altar. Fir beams. Holden Village, Chelan, Wash.

48. Tympanum. Indiana limestone. Immanuel Lutheran Church, Forest City, Iowa.

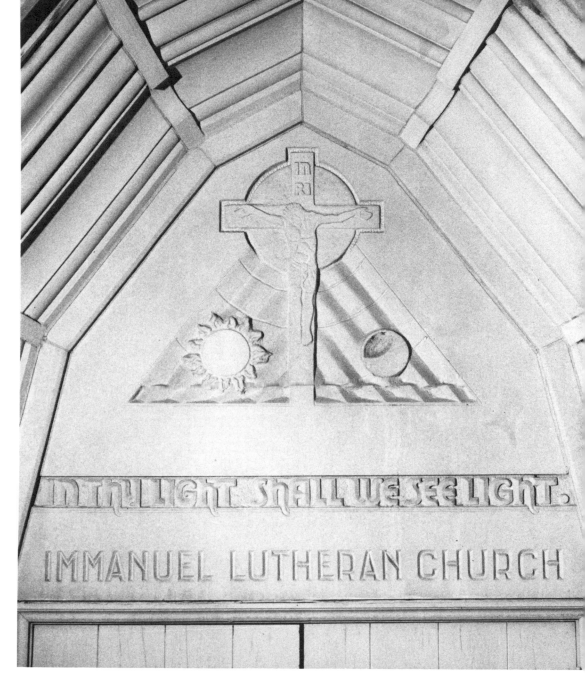

IN THY LIGHT SHALL WE SEE LIGHT.

IMMANUEL LUTHERAN CHURCH

49. Psalm 100:4-5. *Enter His Gates with Thanksgiving.* Doors of oak, Trinity Lutheran Church, Clinton, Minn.

50. *The Good Shepherd.* Wrought iron and cedar inserts on exterior wall, Good Shepherd Lutheran Church, International Falls, Minn.

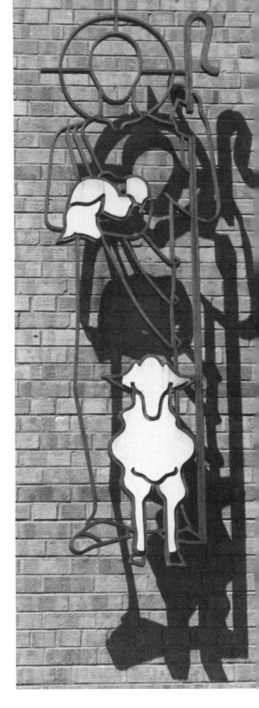

51. Brick relief. Good Shepherd Lutheran Church, Rock Island, Ill.

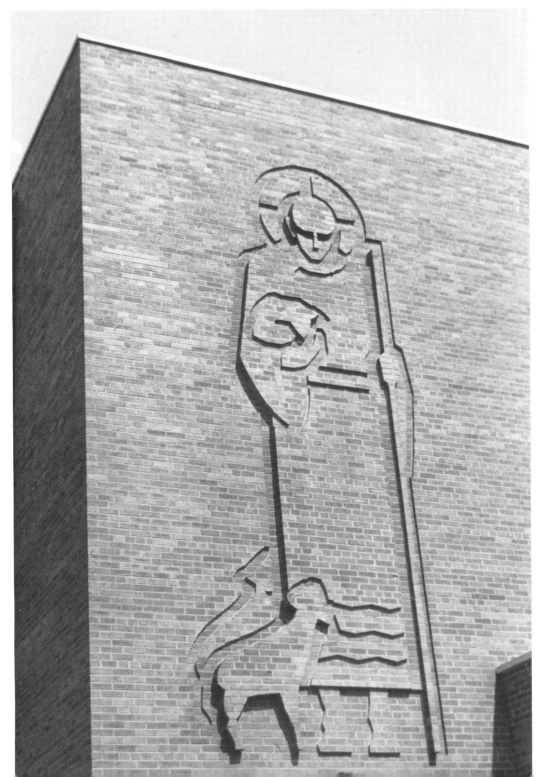

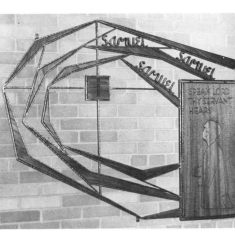

52. *Samuel.* Wrought iron and mahogany. Our Savior's Lutheran Church, Austin, Minn.

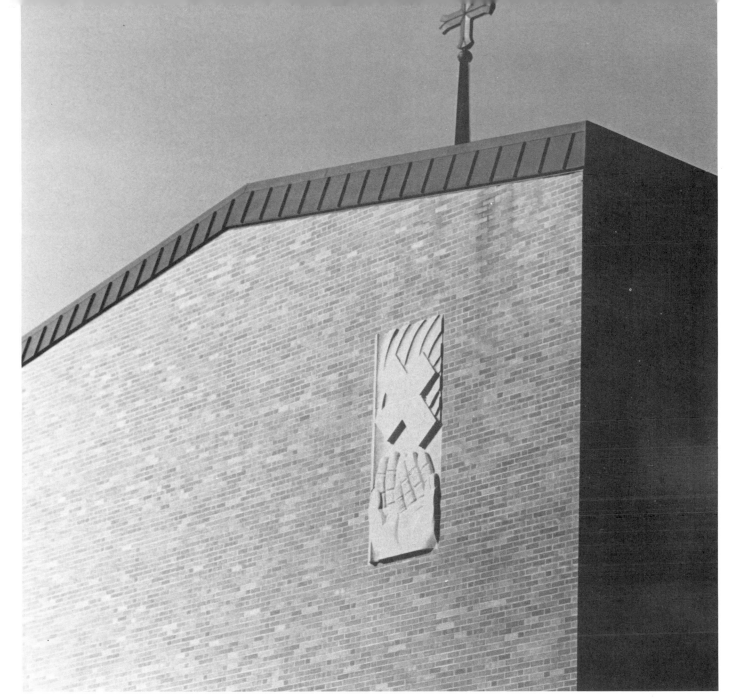

53. *Symbol of Receiving the Gospel.* Kasota stone relief. Our Savior's Lutheran Church, Austin, Minn.

54. Six carvings on wall back of the altar. *Behold the Man, Way of the Cross, Crucifixion, Resurrection, He Is Risen, Alleluia, My Lord and My God.* Calvary Lutheran Church, Grand Forks, N.D.

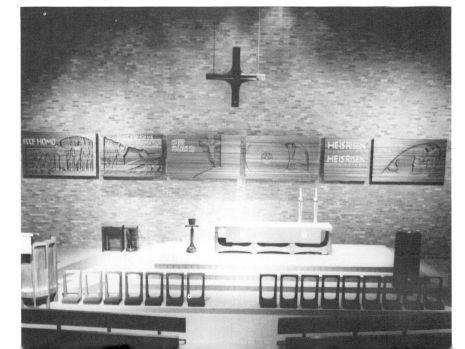

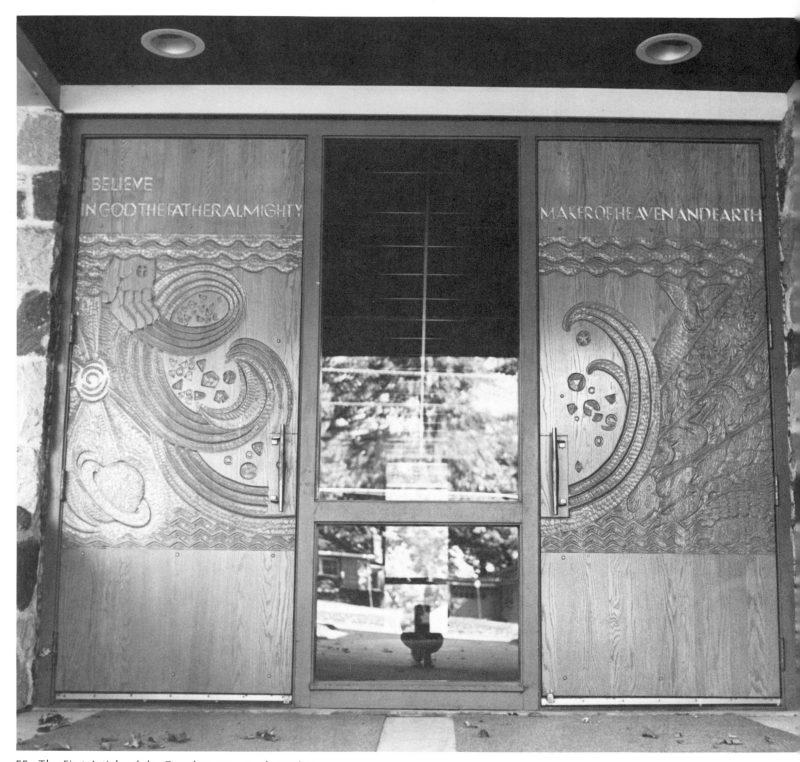

55. *The First Article of the Creed,* sequence of creation.
First door: *Constellations, bird and aquatic life.* Right,
second door: *Flora and Fauna, Man.* Laminated oak doors.
Lake Edge Lutheran Church, Madison, Wis.

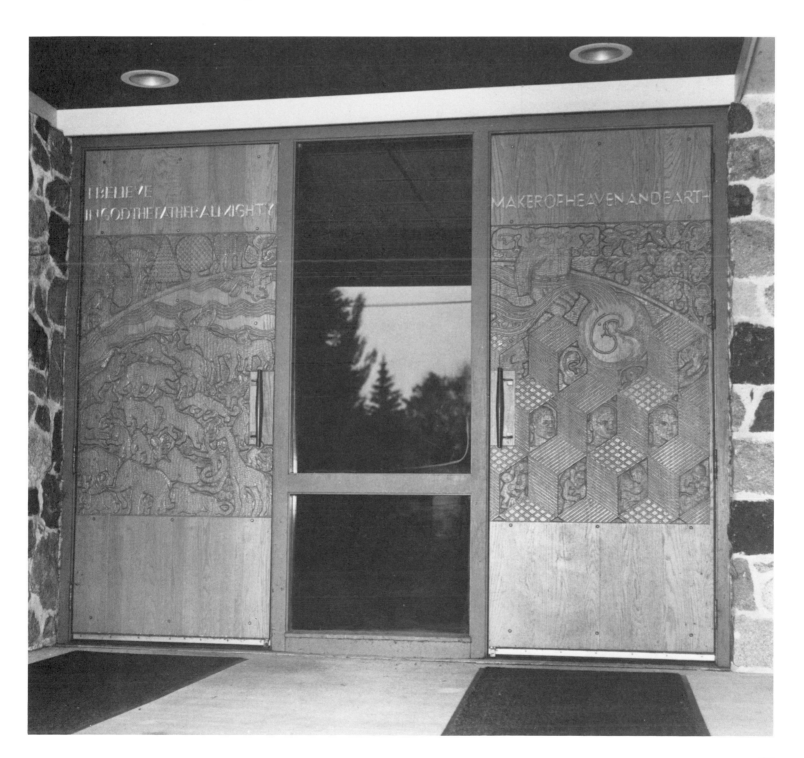

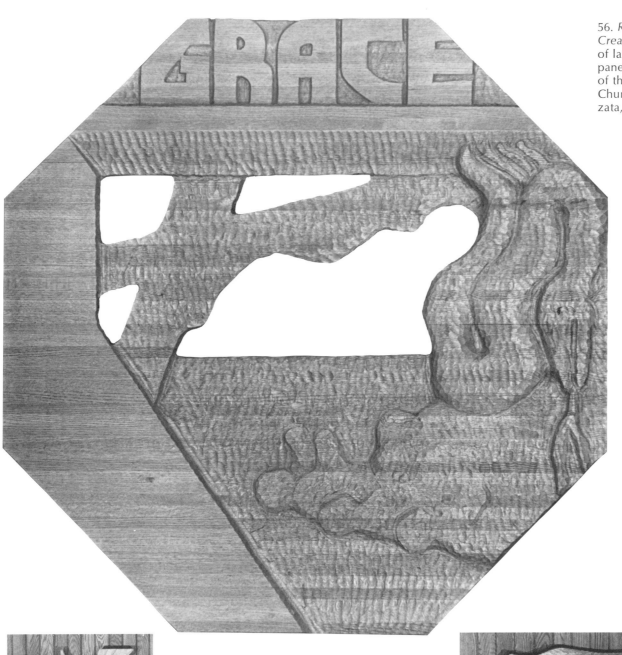

56. *Redemption, Holy Spirit, Creation.* Relief carvings of laminated oak. On paneled walls on either side of the altar. Grace Lutheran Church of Deephaven, Wayzata, Minn.

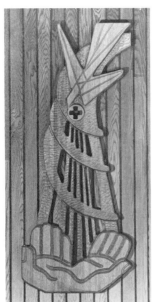

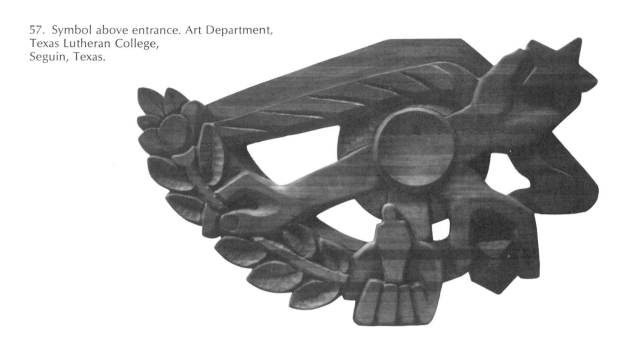

57. Symbol above entrance. Art Department,
Texas Lutheran College,
Seguin, Texas.

58. Advent processional screen. Four laminated oak panels.
Central Lutheran Church, Minneapolis, Minn.

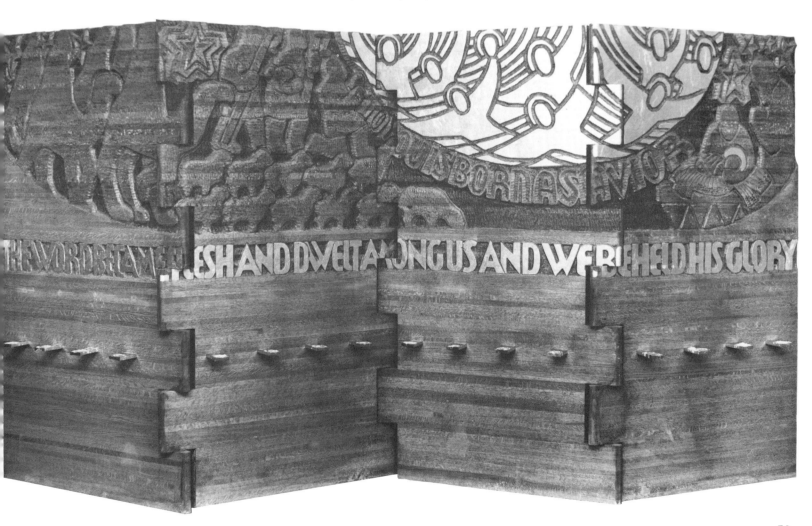

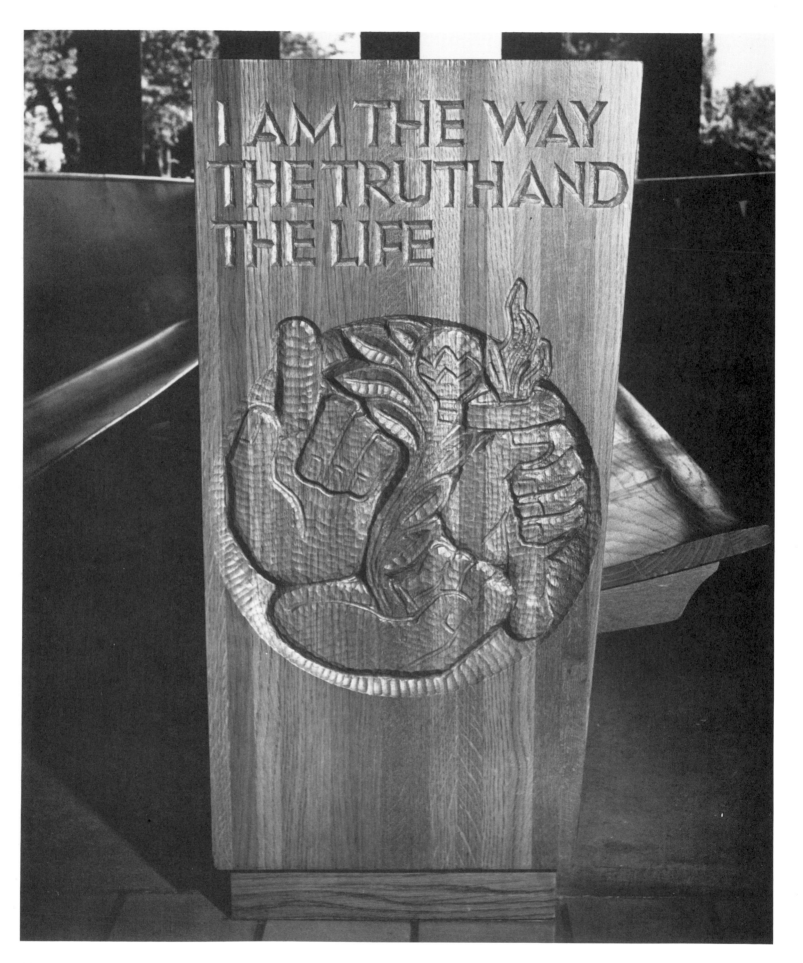

54

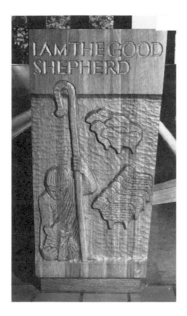

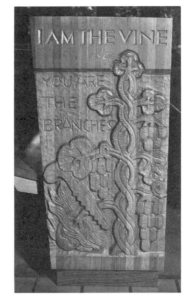

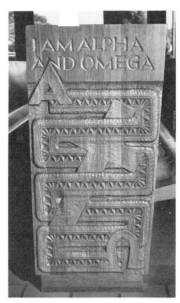

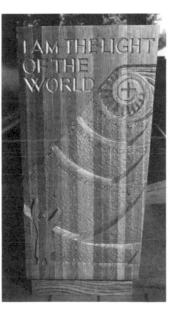

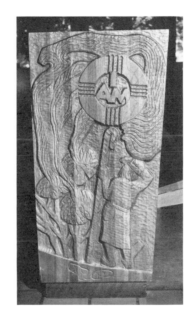

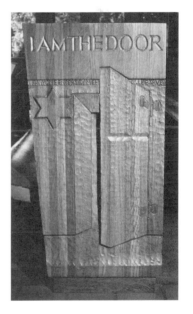

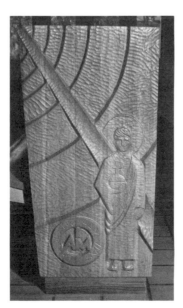

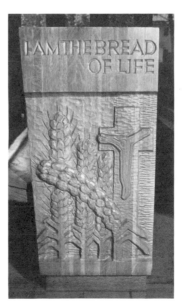

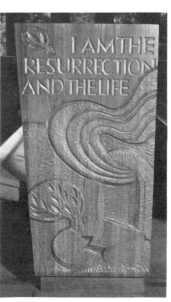

59. Pews. *"I Am,"* center aisle.
First Lutheran Church.
Williston, N.D.

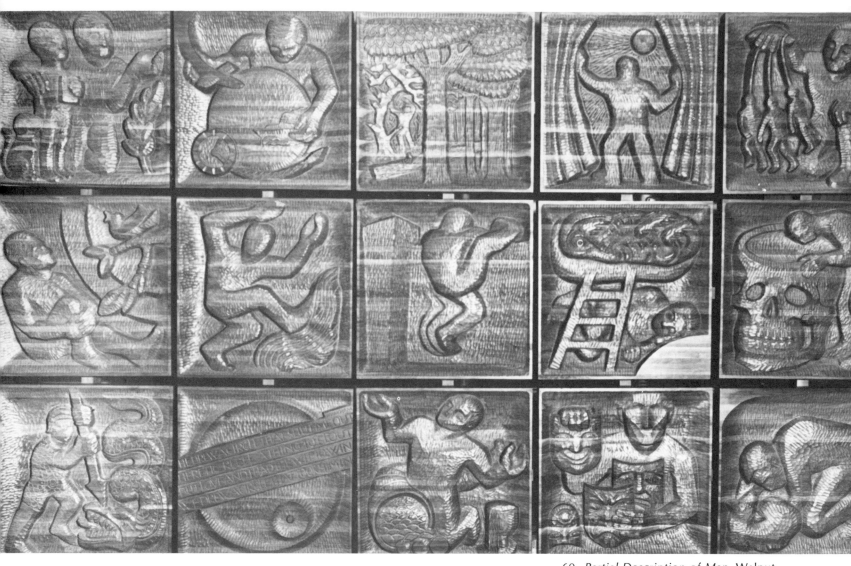

60. *Partial Description of Man*. Walnut. Screen in dining room, Lutheran Brotherhood Building, Minneapolis, Minn.

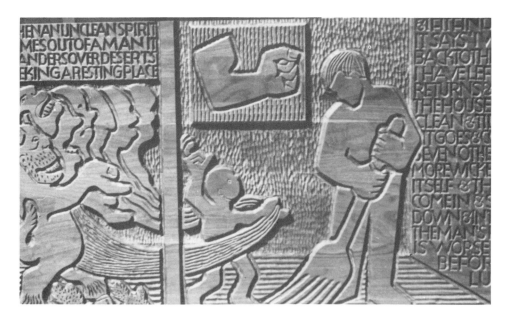

61. *Parable of the Empty Room*. Laminated walnut relief. Trinity Lutheran Church, Moorhead, Minn.

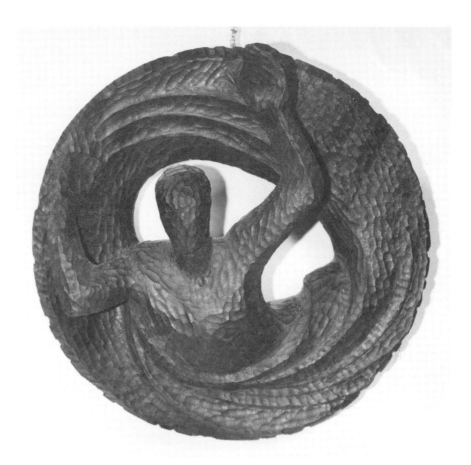

62. *Job 38:1-2*. End-grain laminated mahogany. Reception room, St. John's Lutheran Church, Northfield, Minn.

63. *The Generations Together*. Laminated walnut. Lutheran Home of the Good Shepherd, Havre, Mont.

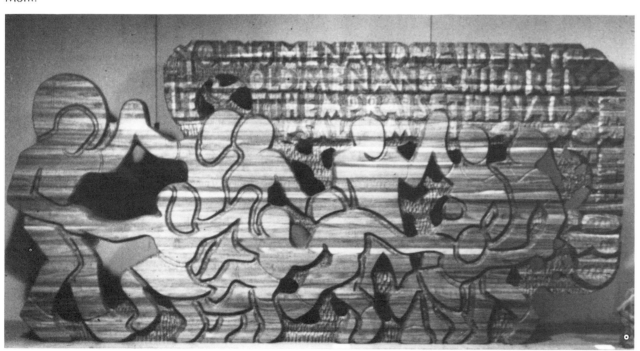

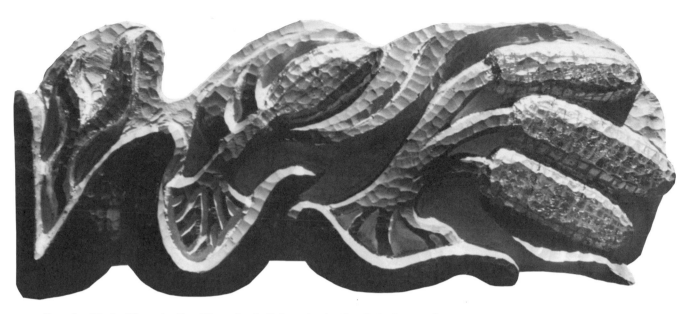

64. *First the Blade, Then the Ear, Then the Full Corn in the Ear.* Polychromed white pine on wall behind font. Zion Lutheran Church, Dysart, Iowa.

65. *Spreading the Message.* Oak. Above exit at Trinity Lutheran Church, Moorhead, Minn.

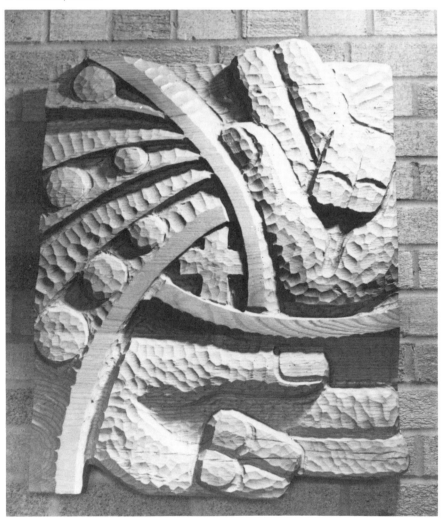

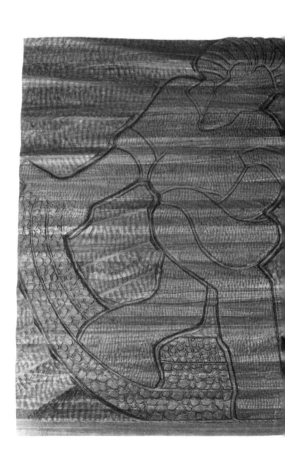

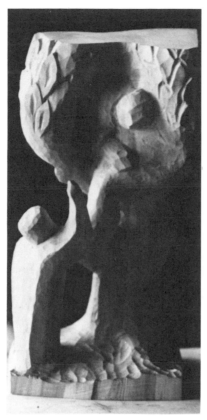

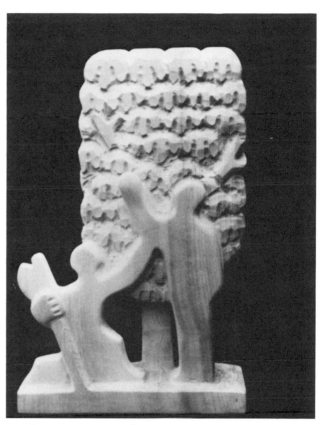

66. *Zacchaeus*. Sycamore.

67. *Barren Fig Tree*. Luke 13:6-9. Myrtle.

68. *Parable of the Sower*.
Walnut. Narthex of Olivet
Lutheran Church, Fargo, N.D.

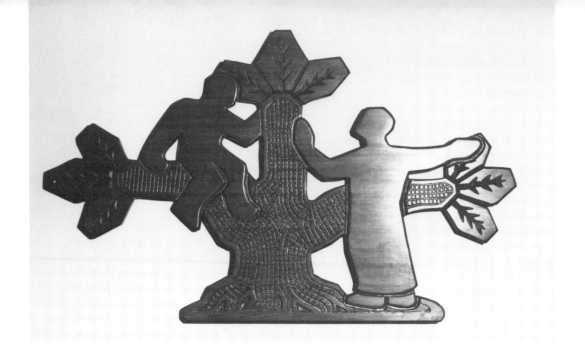

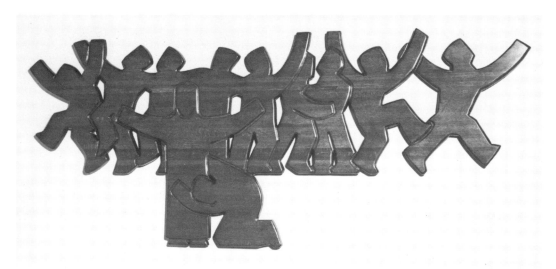

69. Three relief carvings: Above: *Zacchaeus*. Laminated oak. Entrance to chapel, Left: *Ten Lepers*. Laminated oak. Entrance to chapel, Below: *David*. Mahogany. Choir room, Como Park Lutheran Church, St. Paul, Minn.

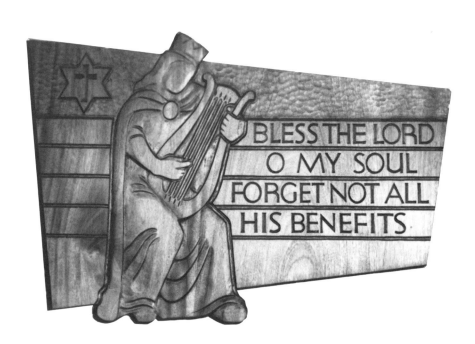

BLESS THE LORD O MY SOUL FORGET NOT ALL HIS BENEFITS

70. Dove symbol above font. St. John's Lutheran Church, Northfield, Minn.

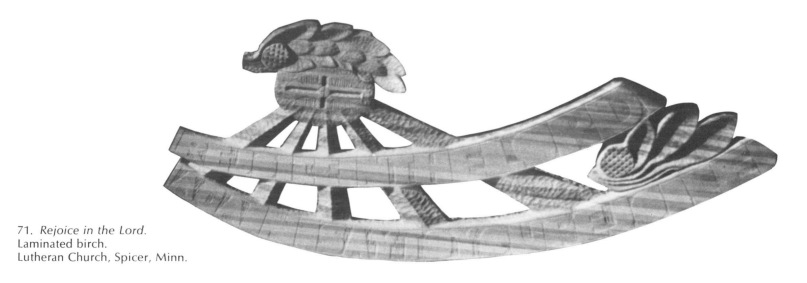

71. *Rejoice in the Lord.*
Laminated birch.
Lutheran Church, Spicer, Minn.

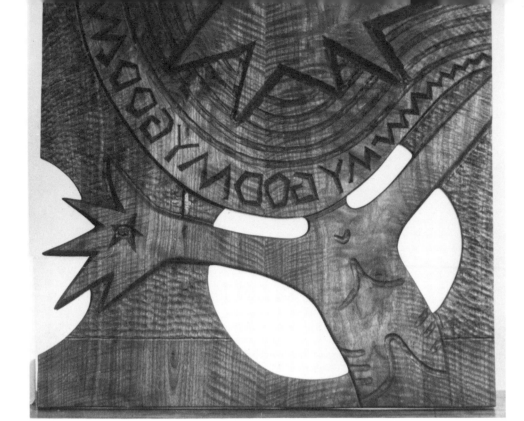

72. *Good Friday Meditation.* Walnut.

Below, left to right:
73. *Jesus at the Door.* Walnut. Bethlehem
Lutheran Church, Aberdeen, S.D.
74. *Jesus at the Door.* Walnut.
75. *Door Ajar.* Cedar.
76. *Isaiah 53:2.* Olive wood from
Bethlehem.

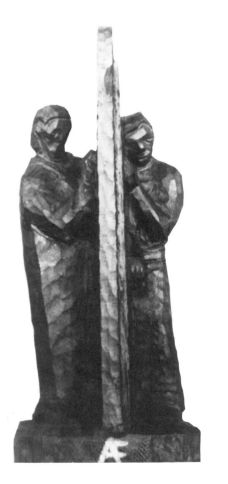
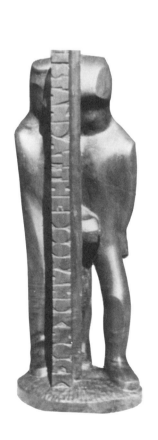
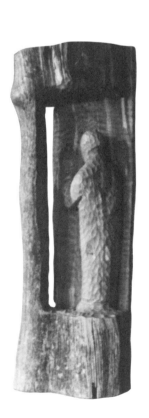

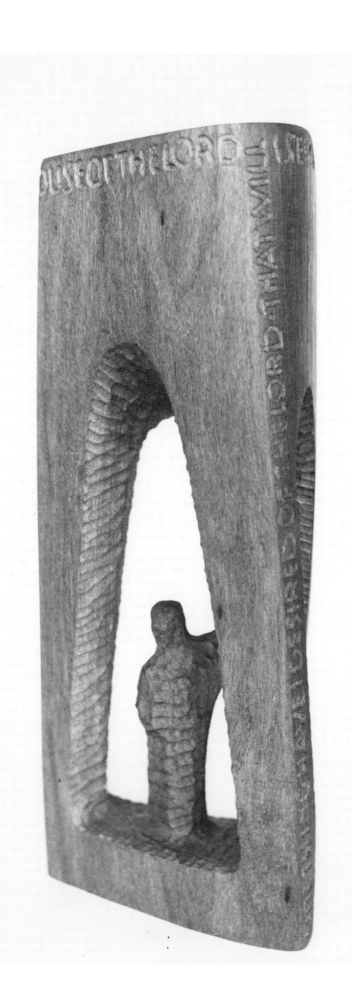

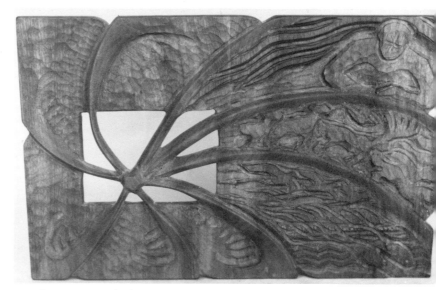

77. *Genesis, Spiral of Creation.* Walnut.

78. *Psalm 27.* Mesquite.

79. *Jeremiah 8:11.* Pear. Two views.

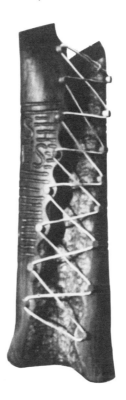

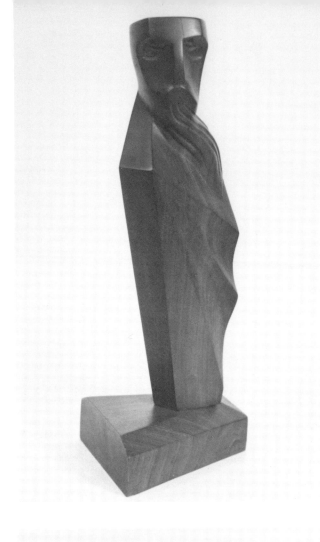

80. *Abraham*. Unidentified wood from Tanzania.

82. *Abraham*. Butternut.

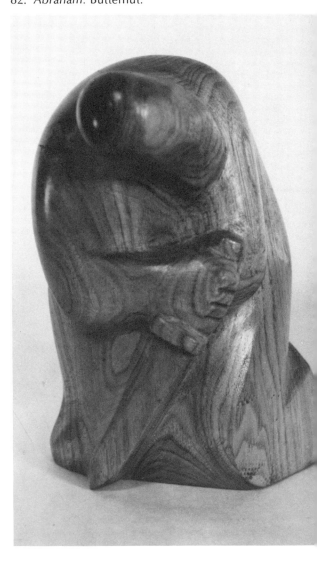

81. *Cain*. Walnut.

64

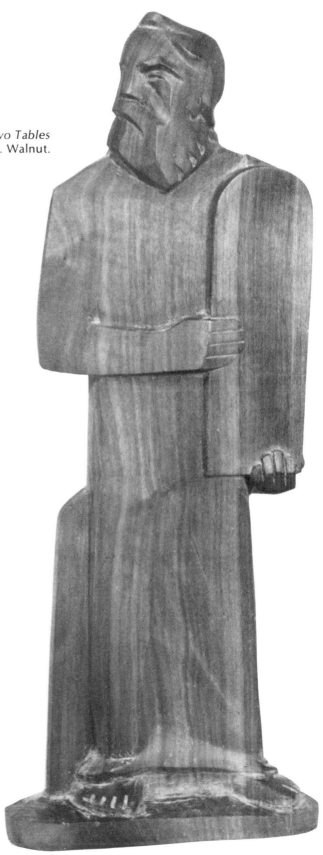

84. *Moses and the Two Tables of the Law*. Walnut.

83. *Jeremiah 9:1*. Walnut.

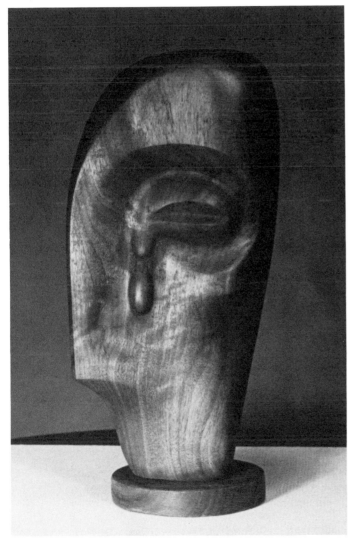

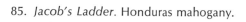

85. *Jacob's Ladder*. Honduras mahogany.

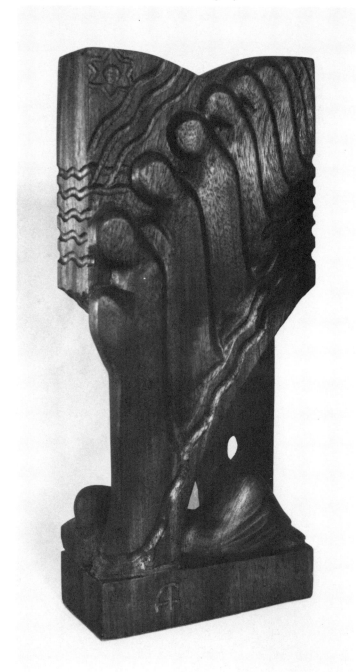

86. *Jacob's Ladder*. Teak.

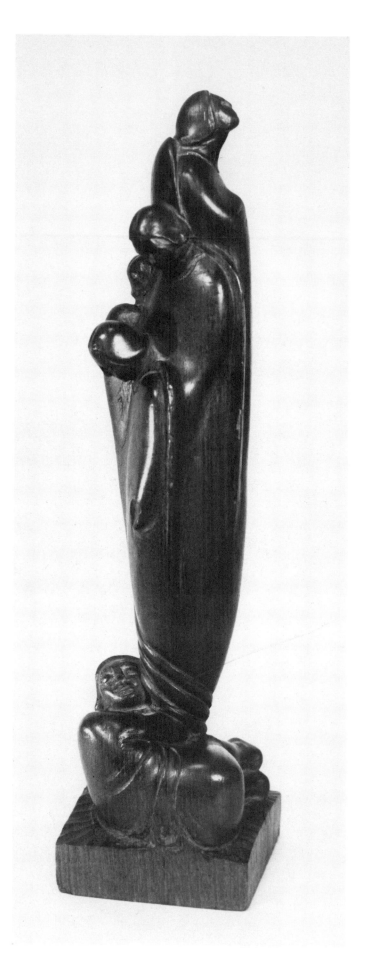

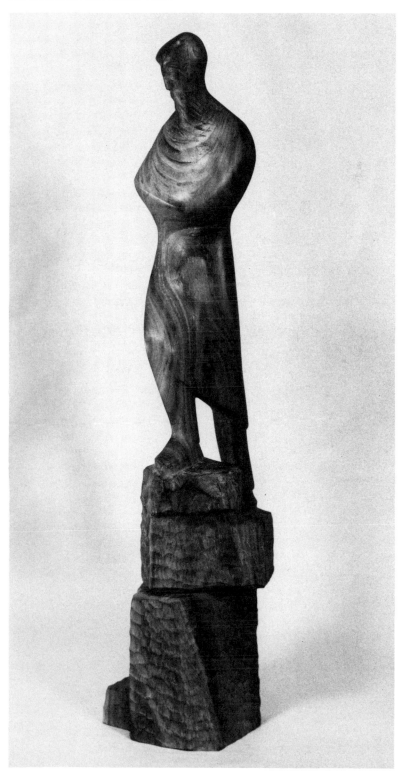

89. *Moses on Mt. Nebo.* Pear.

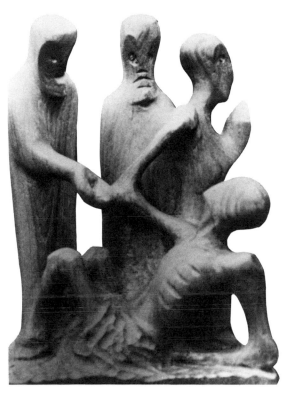

87. *Job and His Miserable Comforters.* Job 16:2. Teak.

88. *Jonah.* Olive.

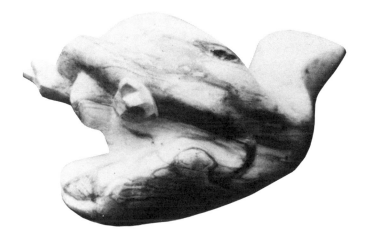

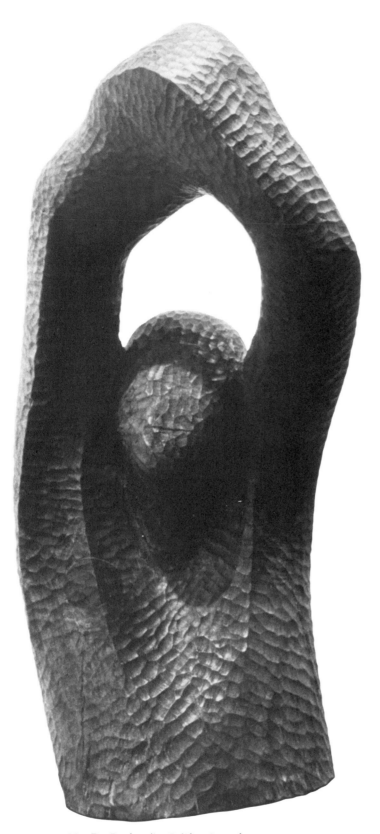

90. *De Profundis*. California walnut.

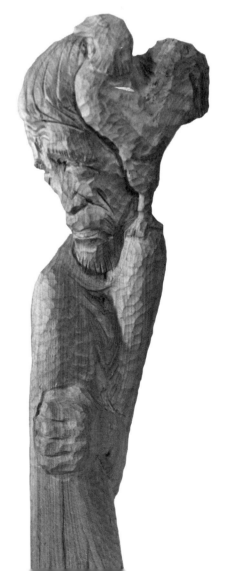

91. *Peter and Rooster*. Butternut.

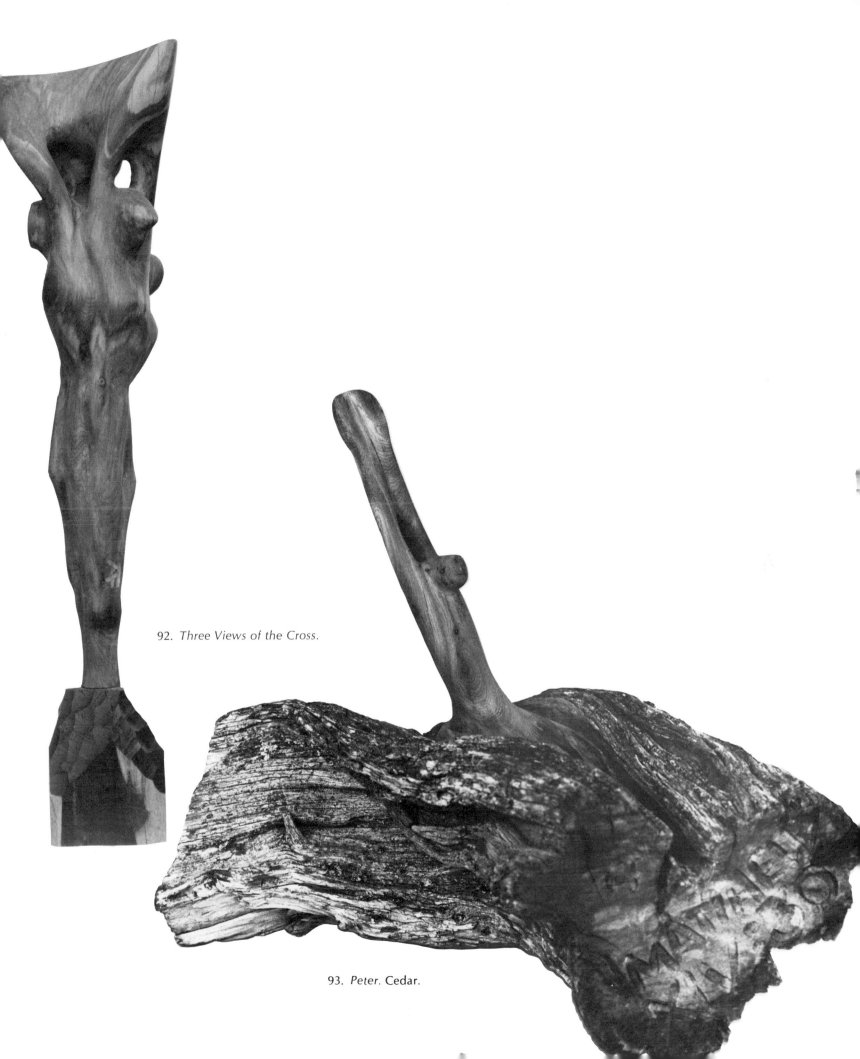

92. *Three Views of the Cross.*

93. *Peter.* Cedar.

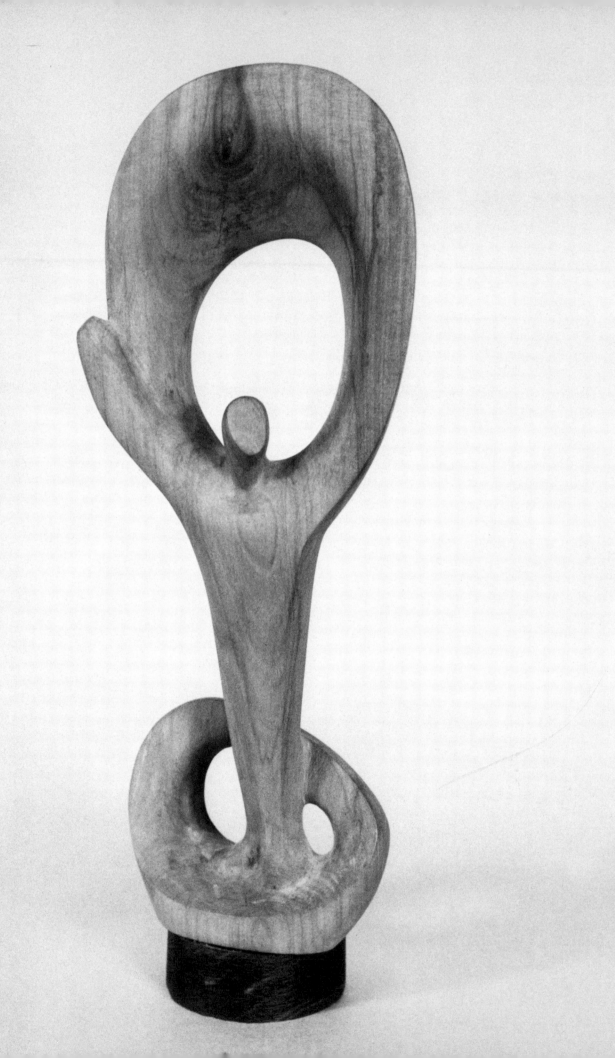

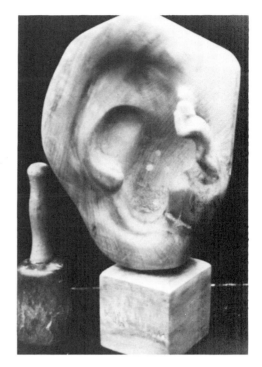

Above, left to right:
95. *Faith*. Cedar.

96. *Hope*. California walnut.

97. *Prophet*. Myrtle.

98. *Benedictus*.
Arizona ironwood.

Opposite page:
94. *Hosanna*. Pear.

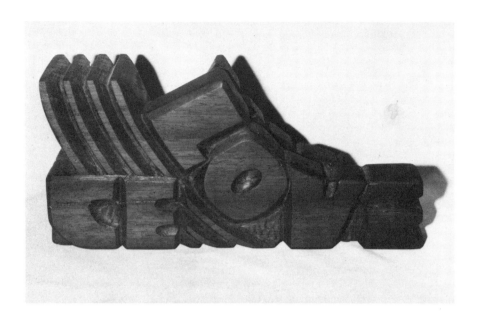

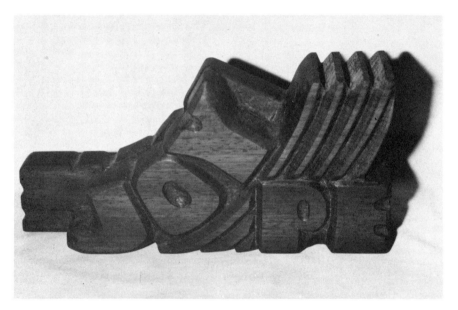

99. *Fruit of the Spirit*. Gal. 5:22.
Padauk. Two views.

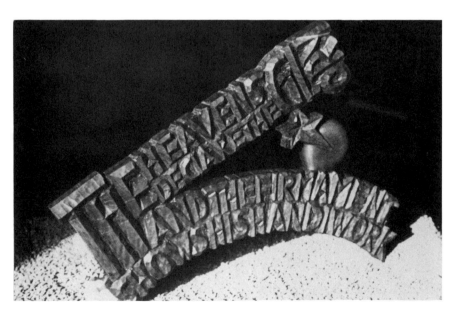

100. Psalm 19. *The heavens declare
the glory*. Walnut.

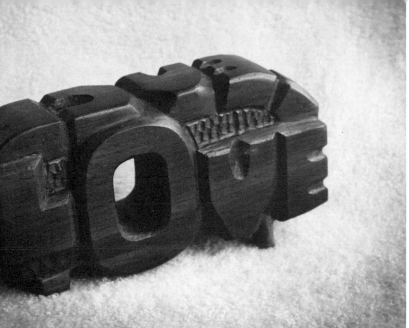

101. *Fruit of the Spirit.* Padauk.

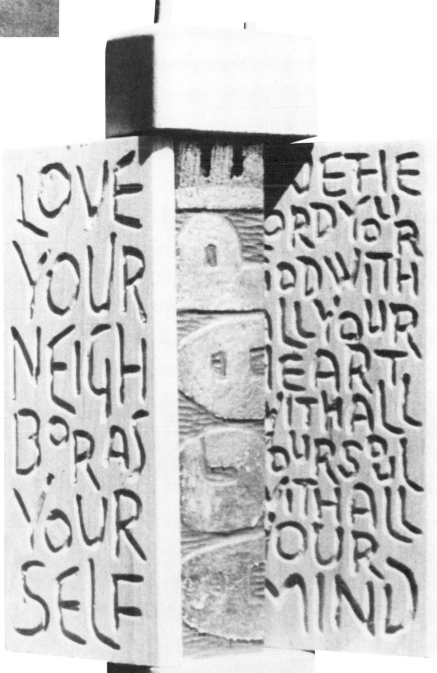

102. *Agape.* Polychromed oak.

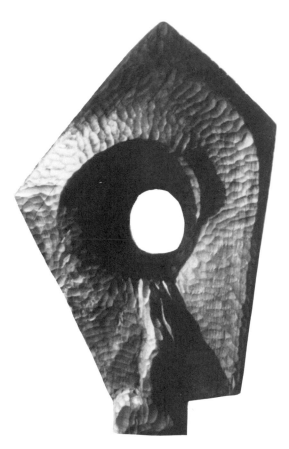

103. John 7:38. *Rivers of Living Water.* Walnut.

104. John 7:38. *Rivers of Living Water.* Orange.

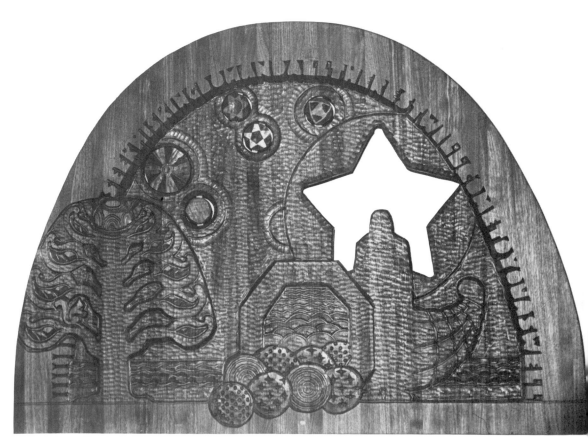

105. *Seek His Kingdom*
Laminated walnut panel above
fireplace mantel.

106. *Table Prayer. Psalm 145:16.* Butternut.

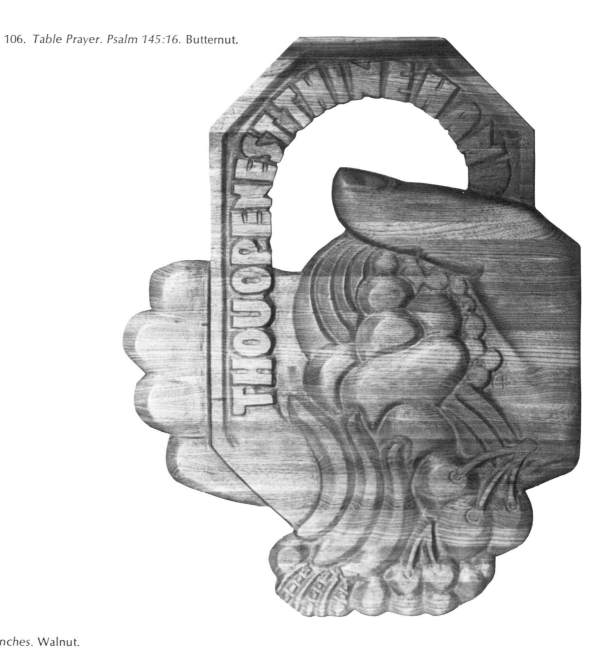

107. *I Am the Vine, You Are the Branches.* Walnut.

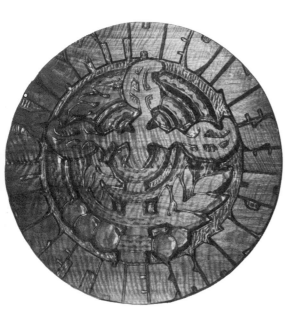

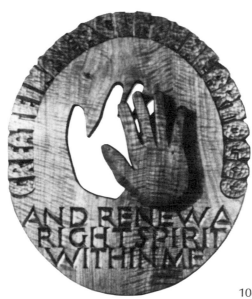

108. *Prayer.* Walnut relief.

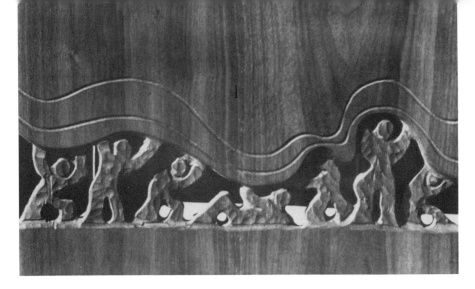

109. *More Light!*
Walnut.

110. *Stars.*
Walnut.

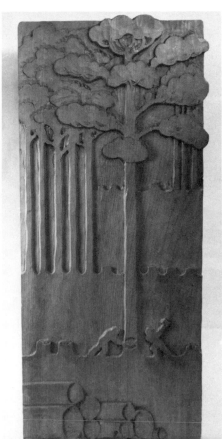

111. *White Pine Industry.*
White pine.

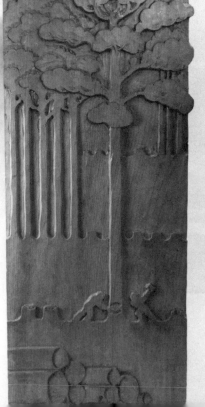

112. *Benediction.*
Rosewood.

76

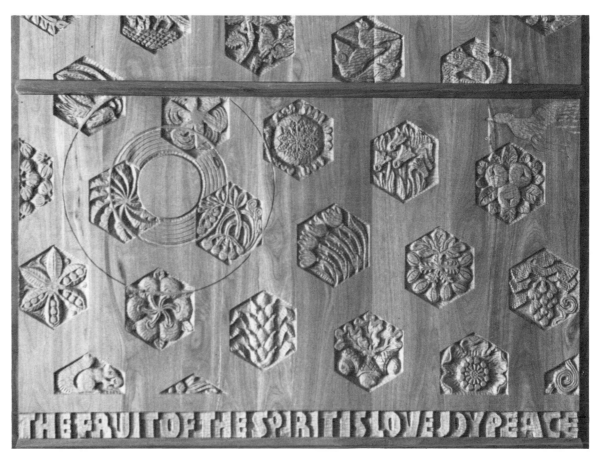

113. *Fruit of the Spirit.* Walnut panels above fireplace.

114. *Lenten Message.* Walnut.

115. *King Olav.* Walnut.

116. *Viking King.* Polychromed pine.

117. *A Tear Is an Intellectual Thing.* (Blake quotation). Butternut.

118. *A Tear Is an Intellectual Thing.* (Blake quotation). Myrtle.

119. *William Blake's Tyger.* Polychromed fir.

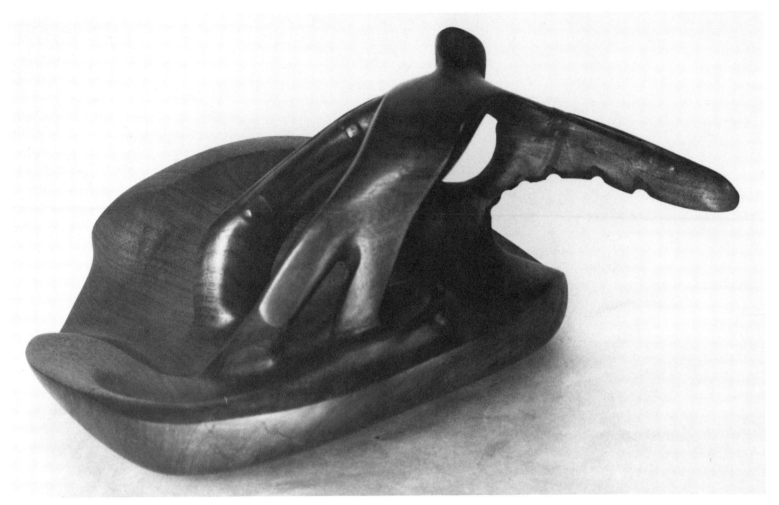

120. *Icarus.* Walnut.

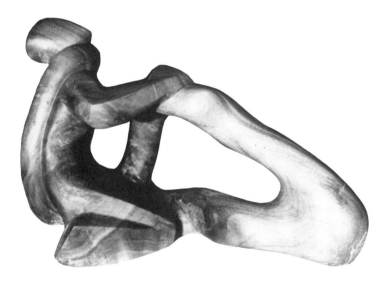

121. *Version of Laocoon.* Walnut.

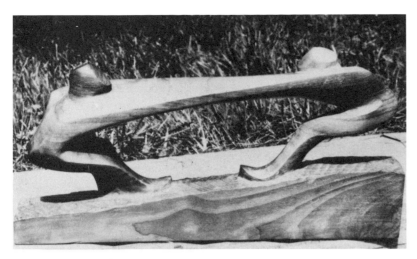

122. *Tension*. Walnut.

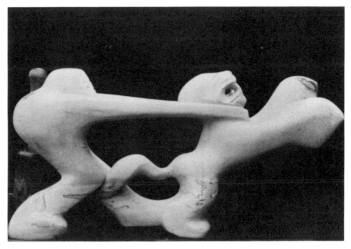

123. *Tension*. Myrtle.

124. *Current*. Indiana cedar.

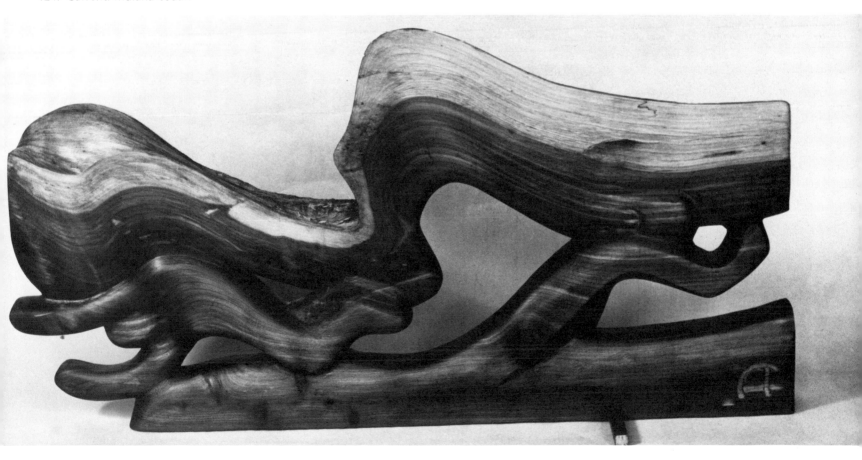

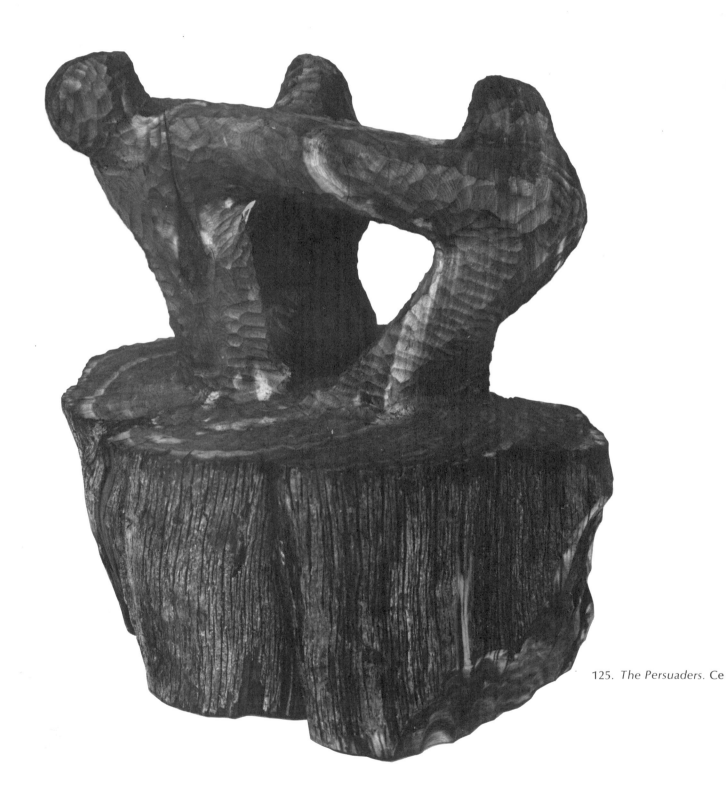

125. *The Persuaders*. Ce

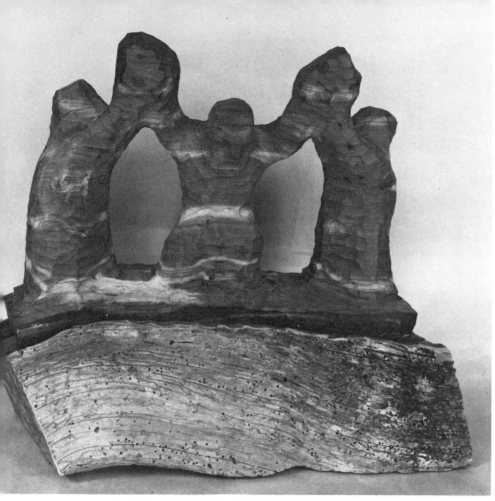

126. Aaron, Moses, and Hur. Cedar.

127. Protest Marcher. Walnut.

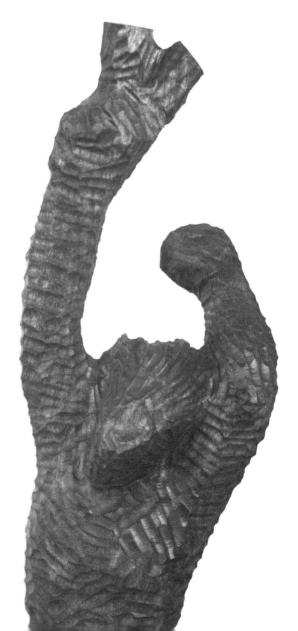

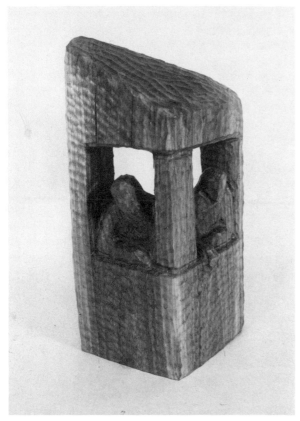

128. *Looking*. Walnut.

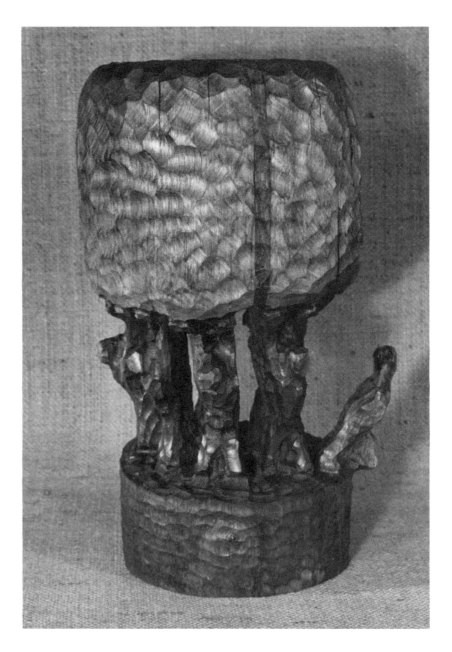

129. *Leaving the Group*. Walnut.

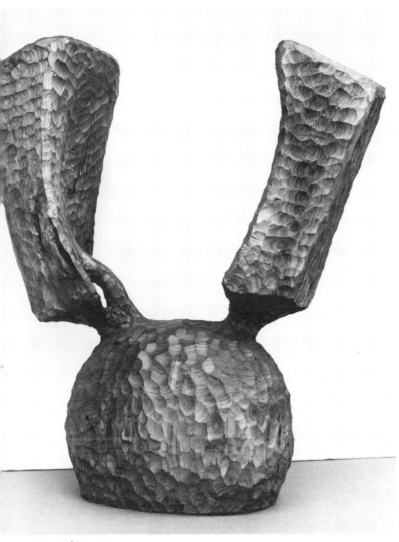

130. *Schizo*. Butternut.

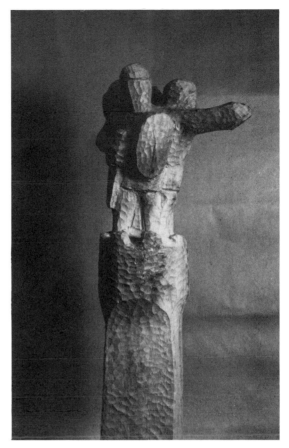

131. *Watchmen*. Pear.

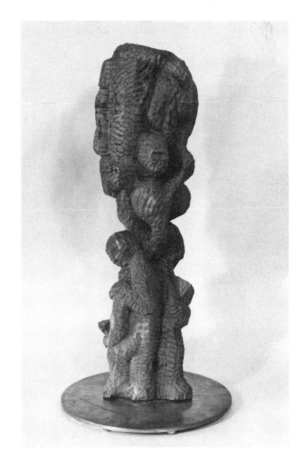

132. *Paul Ricoeur Symbol*. Cedar.

133. *Climbers.* Cedar.

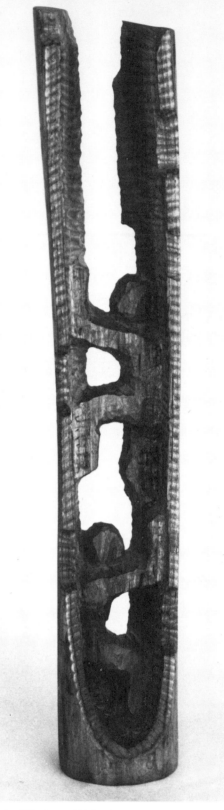

134. *Climbers.* Walnut.

86

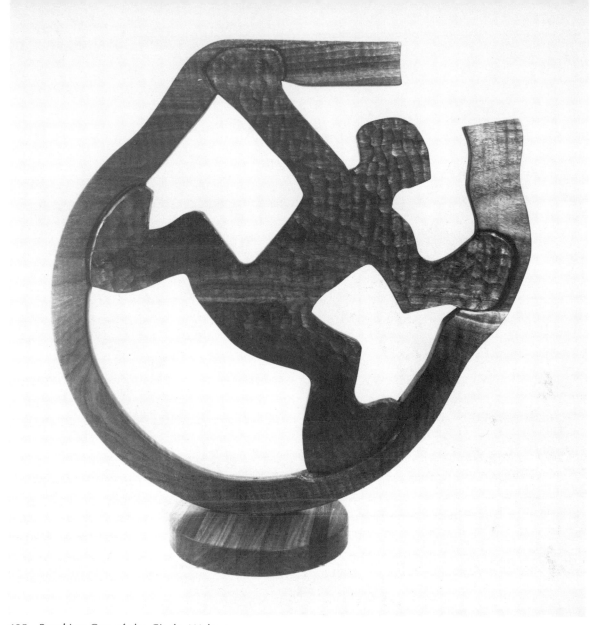

135. *Breaking Out of the Circle.* Walnut.

136. *Wanderer and Dog.* Walnut.

137. *Rockhopping.* Walnut.

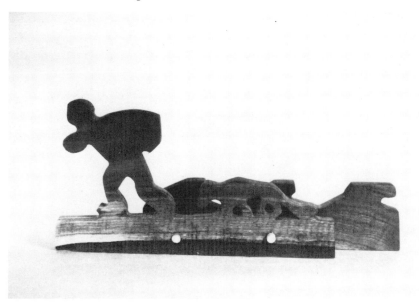

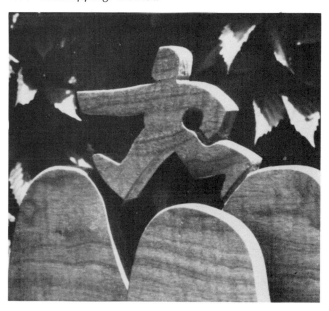

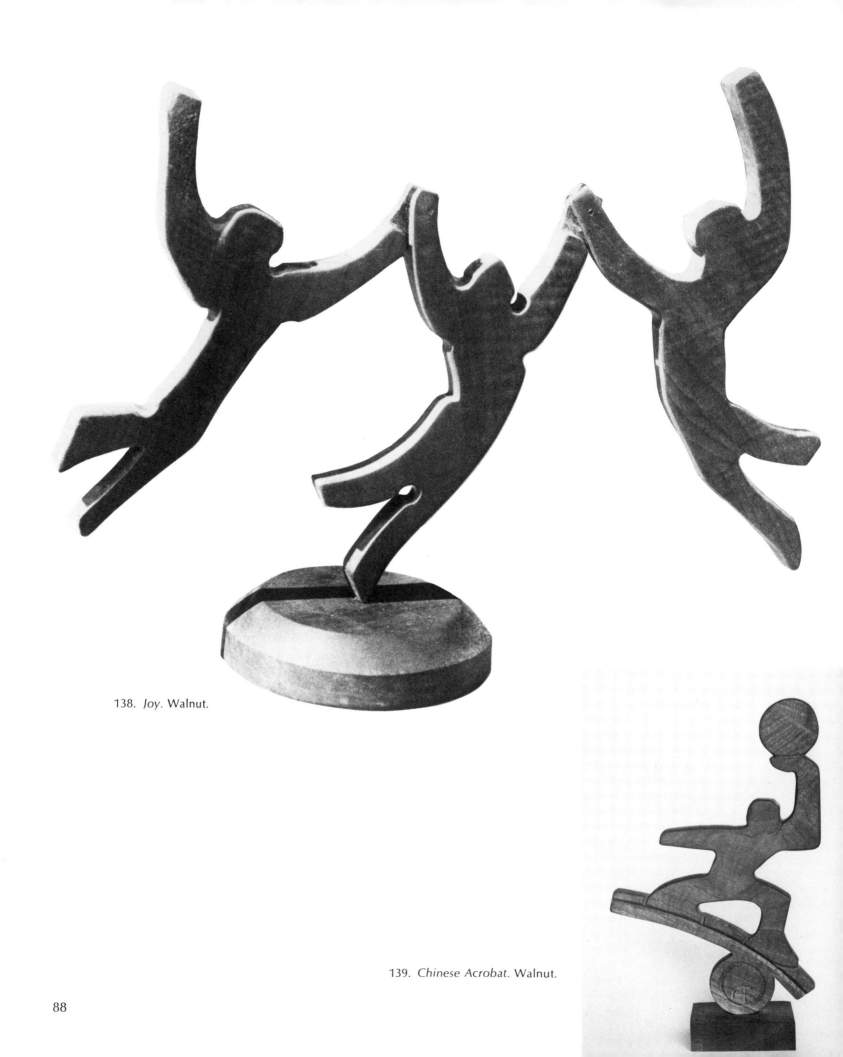

138. *Joy*. Walnut.

139. *Chinese Acrobat*. Walnut.

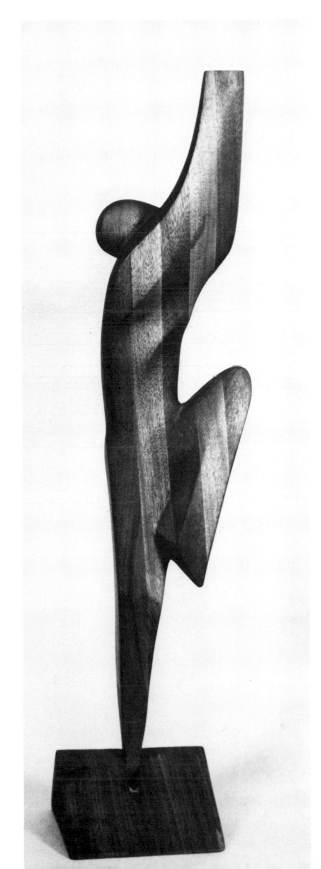

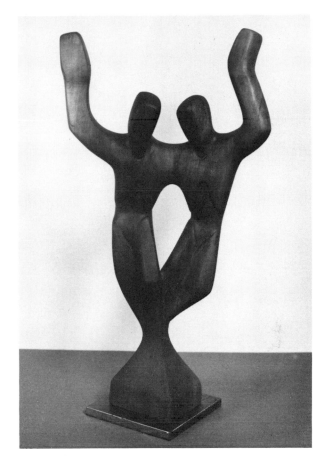

141. *Balance*. Pear.

140. *The Dancer*. Laminated mahogany.

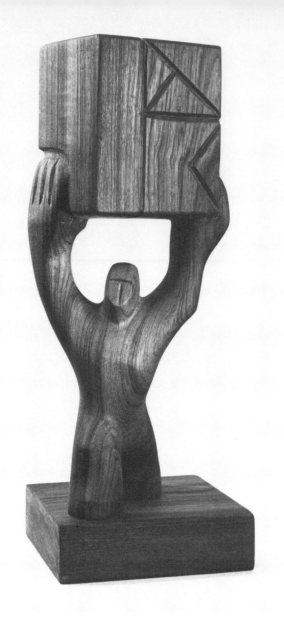

142. *I Am*. Teak.

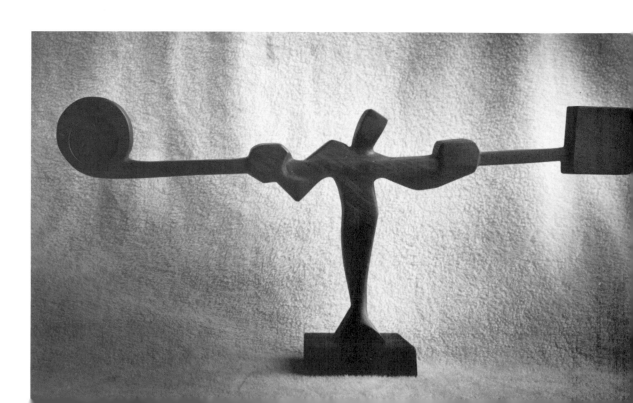

143. *Balance*. Walnut.

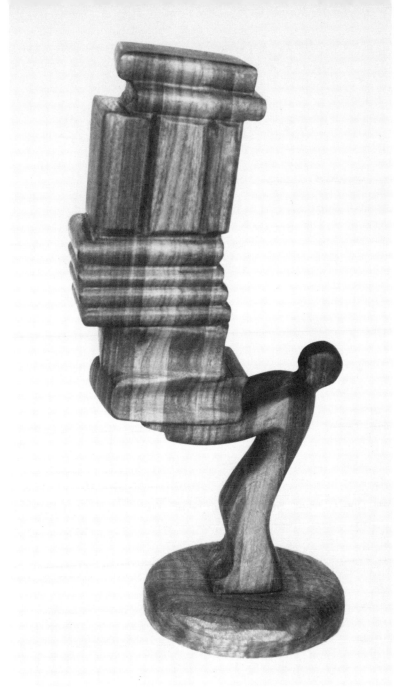

144. *The Librarian.* Laminated walnut.

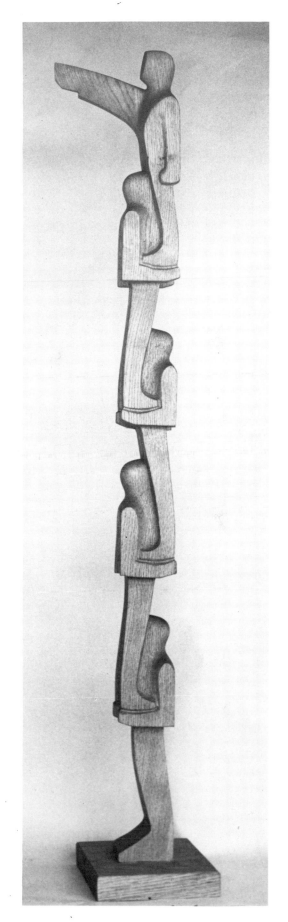

145. *Teacher.* Oak.

146. *Sadness*. Unidentified wood from Brazil.

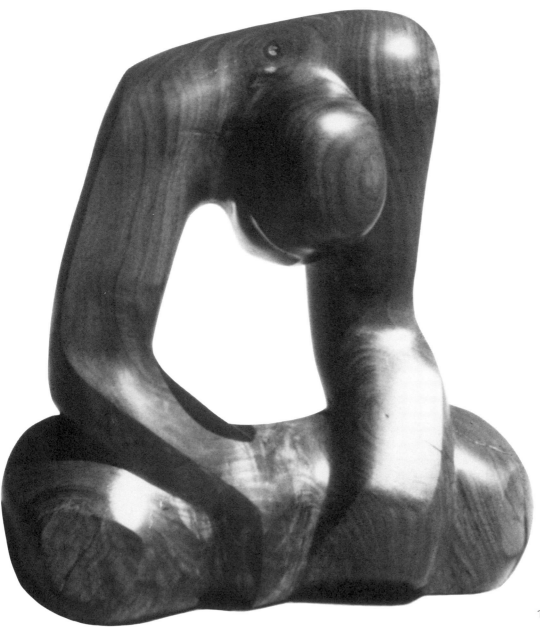

147. *Introspection*. Walnut.

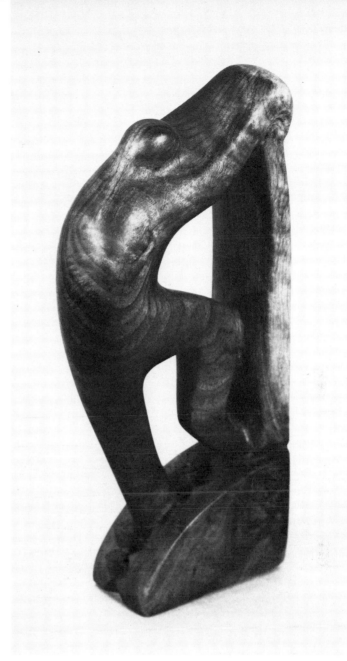

149. *Frustration*. Walnut.

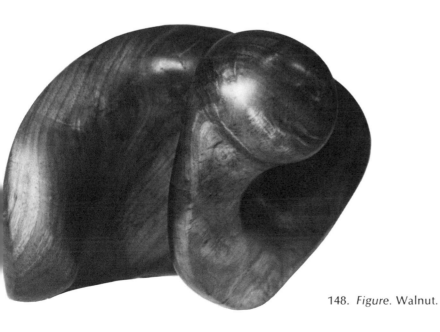

148. *Figure*. Walnut.

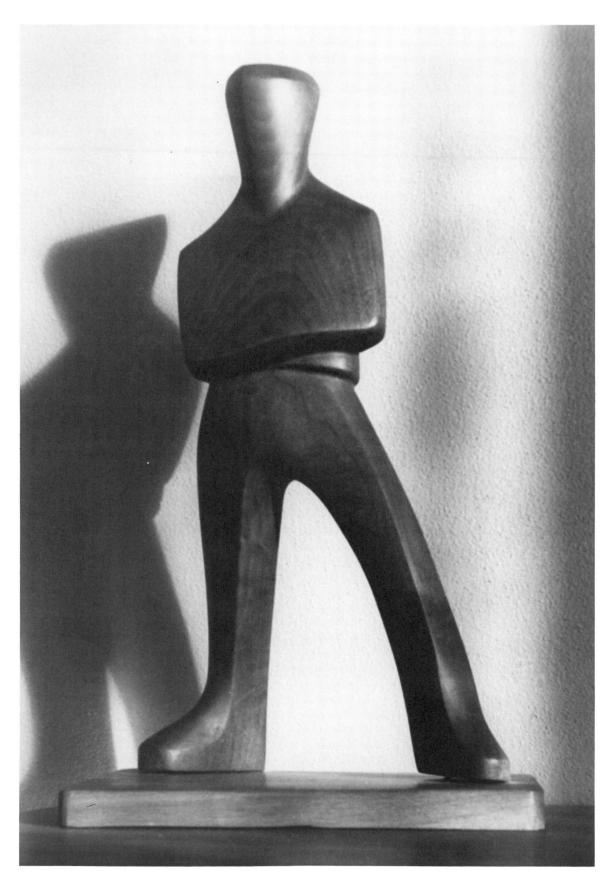

150. *Self-Assurance*. Walnut.

151. *Marriage*. Mahogany.

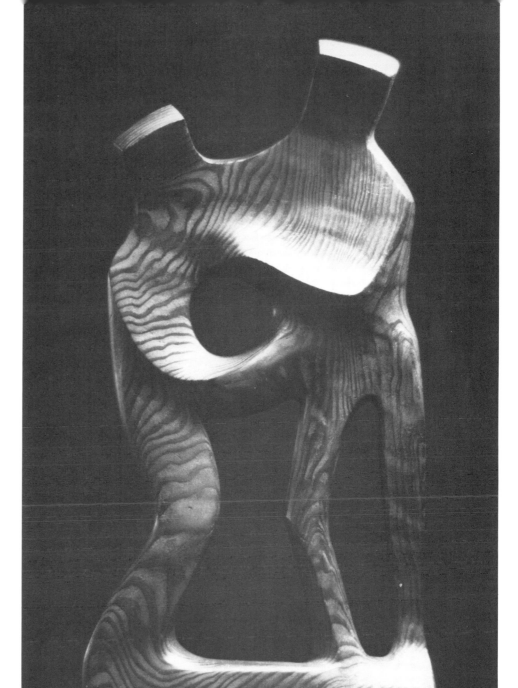

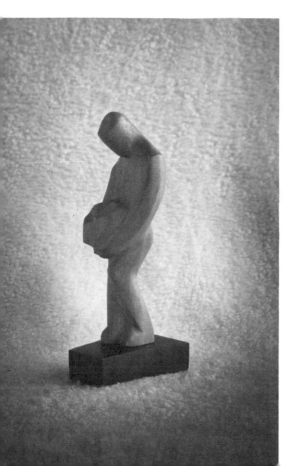

152. *Load*. Myrtle.

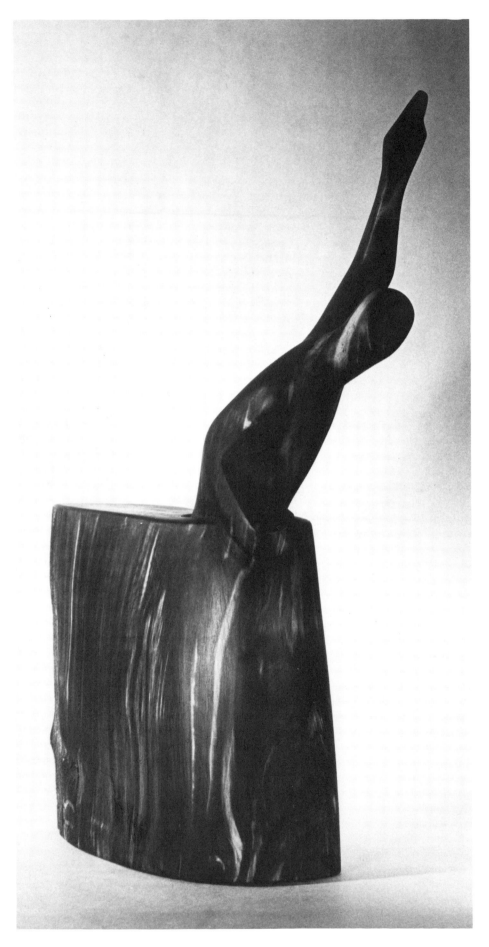

153. *Urgency of Message.* Cedar.

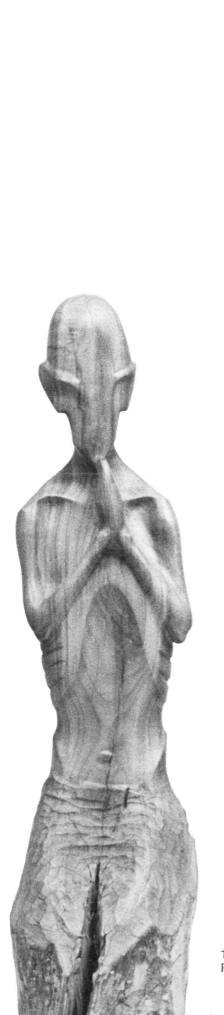

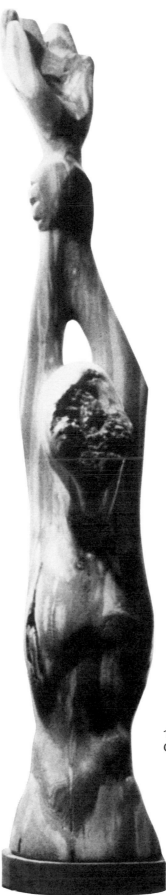

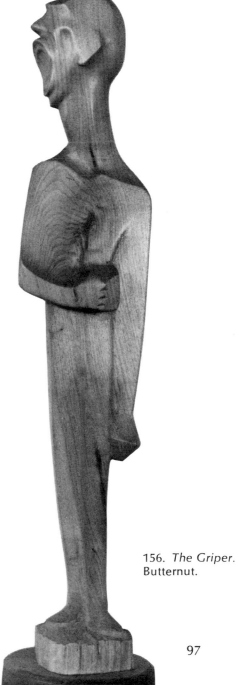

155. *Despair.*
Cedar.

156. *The Griper.*
Butternut.

154. *Dietary Piety.*
Pear.

97

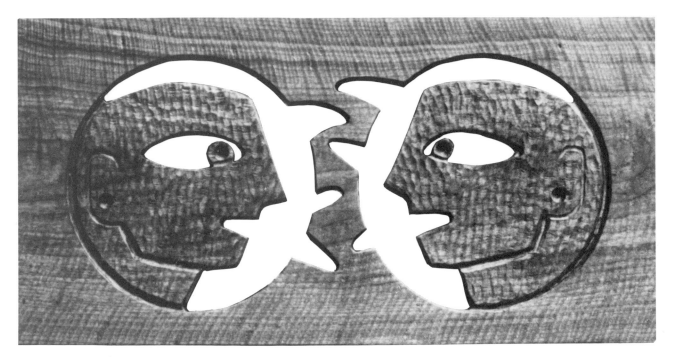

157. *Negotiating*. Walnut.

158. *Thinking (whatever that is)*. Teak.

159. *Listening Through a Crack in the Wall*. Walnut.

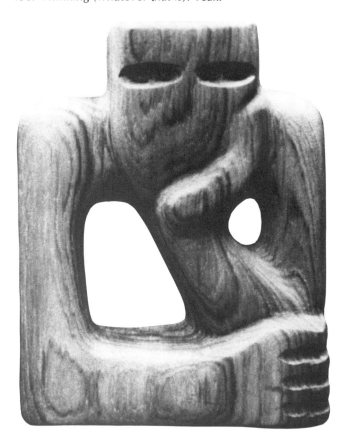

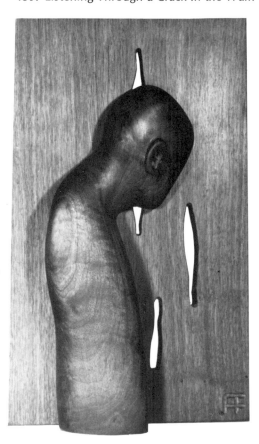

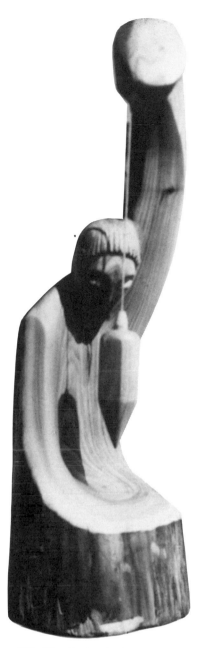

160. *The Perfectionist*. Butternut.

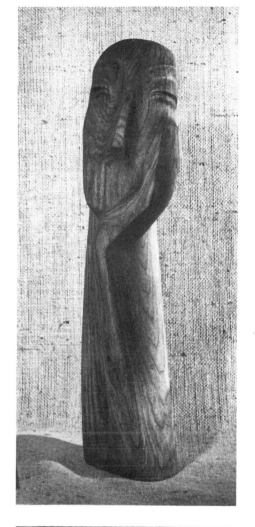

161. *The Dreamer*. Mesquite.

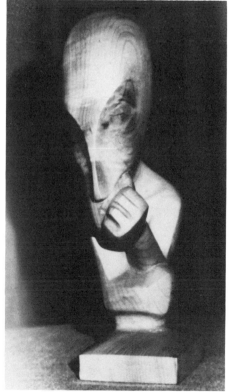

162. *The Egghead*. Myrtle.

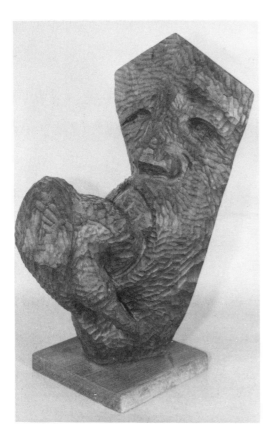

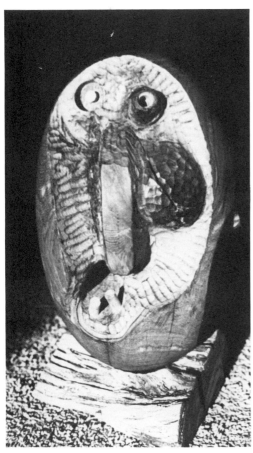

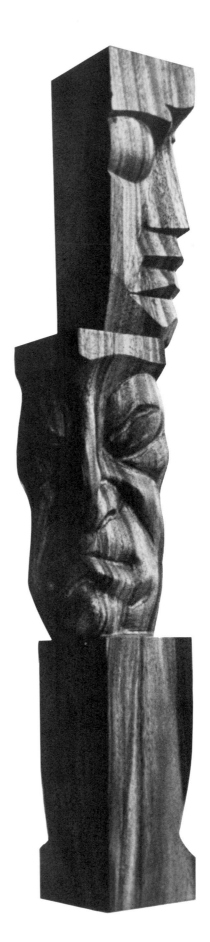

163. *Eating Crow*.
Walnut.

164. *Troll*. Cedar.

165. *Three Faces*.
Monkeypod.

167. *Hand.* Walnut.
Two views.

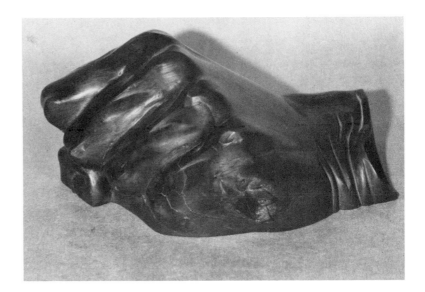

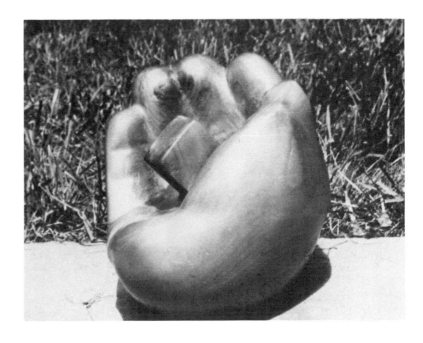

168. *Gambler's Hand.*
Myrtle.

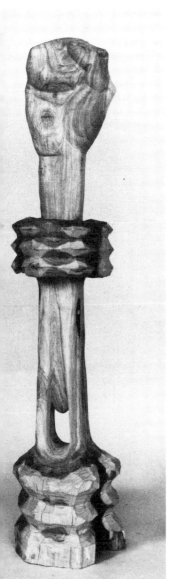

166. *Promethean Symbol.* Texas cedar.

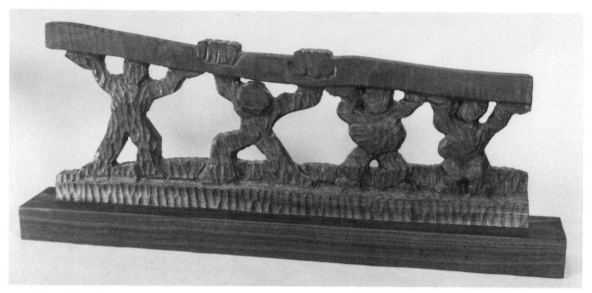

169. *Lowering the Boom*. Walnut.

170. *Teamwork*. Walnut.

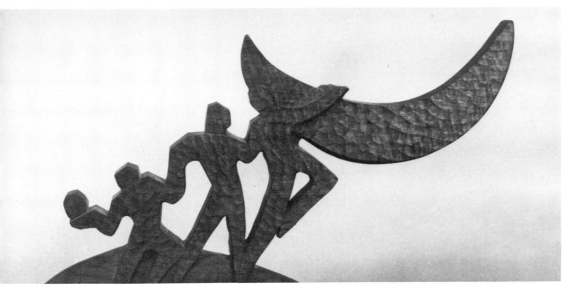

171. *Beyond the Moon*. Walnut.

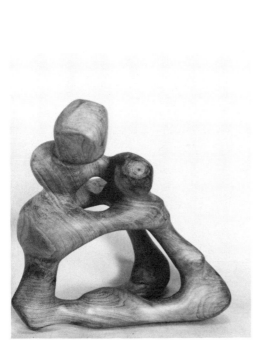

172. *Struggle*. Cedar.

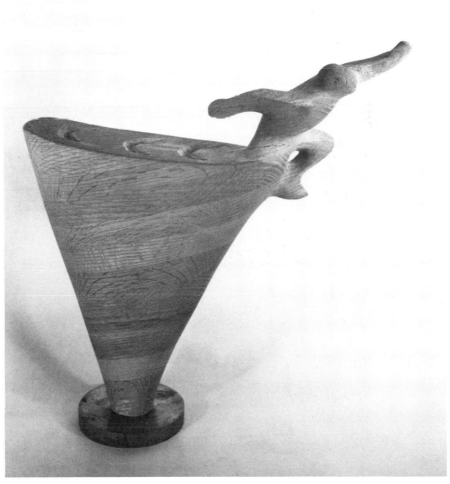

173. *Escape*. Laminated oak.

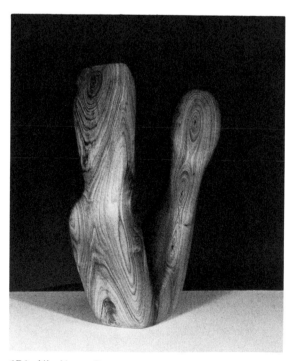

174. *Yin-Yang*. Butternut.

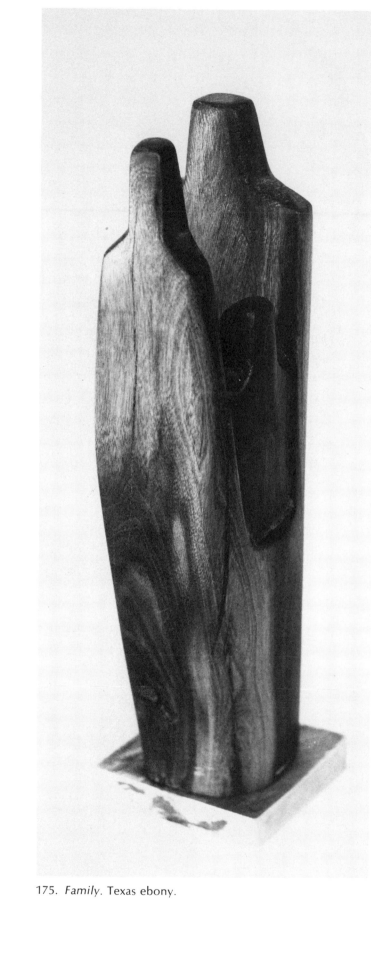

175. *Family*. Texas ebony.

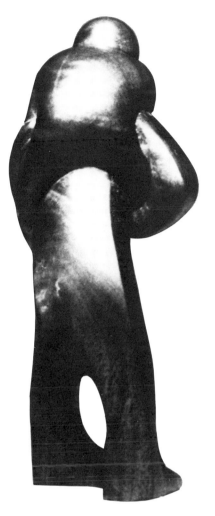

176. *Piggyback*. Walnut.

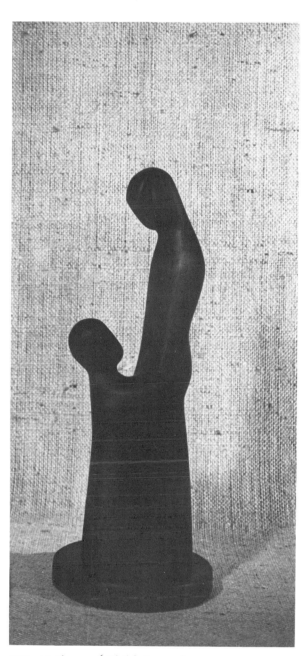

177. *Mother and Child*. Texas ebony.

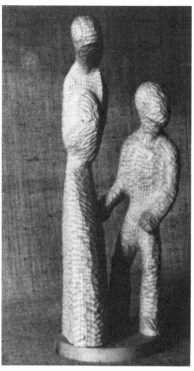

178. *Mother and Son*. Oak.

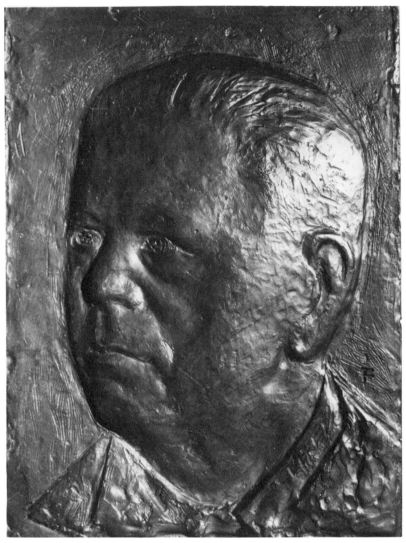

179. *Dr. C. M. Weswig.* Bronze relief.

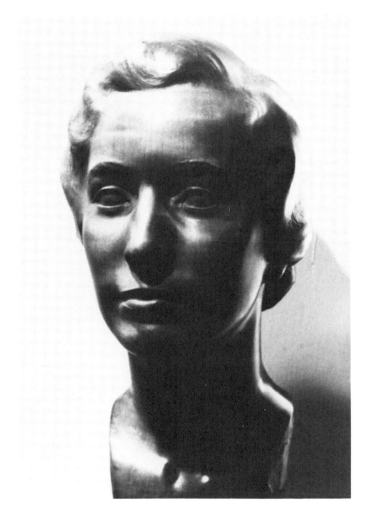

180. *Anne Kellner.* Pear.

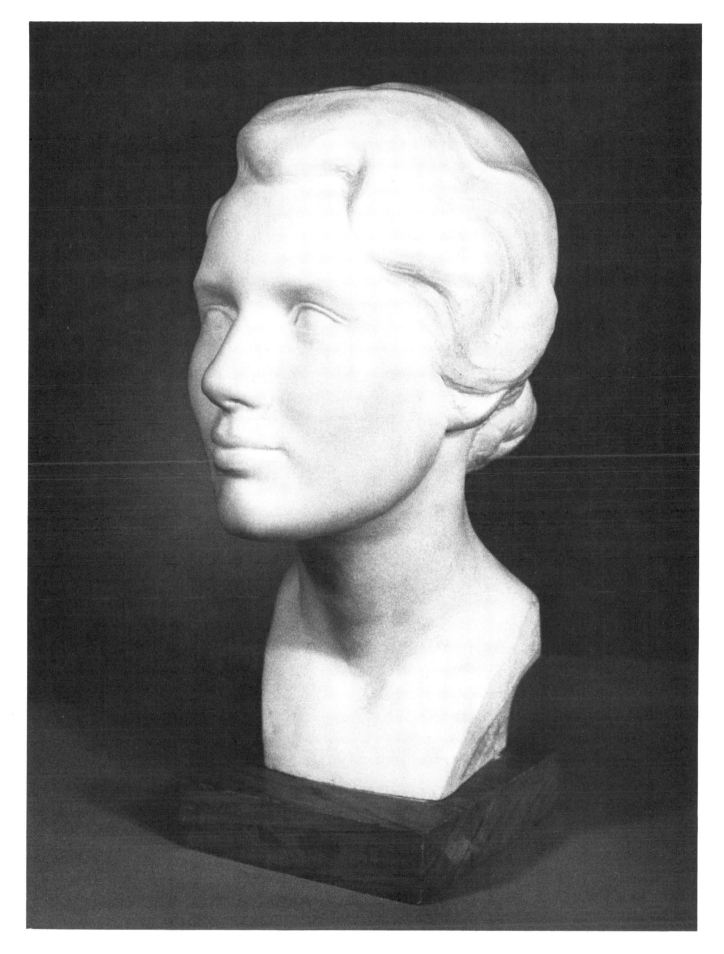

182. *Form in Motion*. Walnut. Two views.

183. *Two Birds Feeding.*
Mahogany.

184. *Cardinal.*
Walnut

185. *The Pecking Order.*
Walnut.

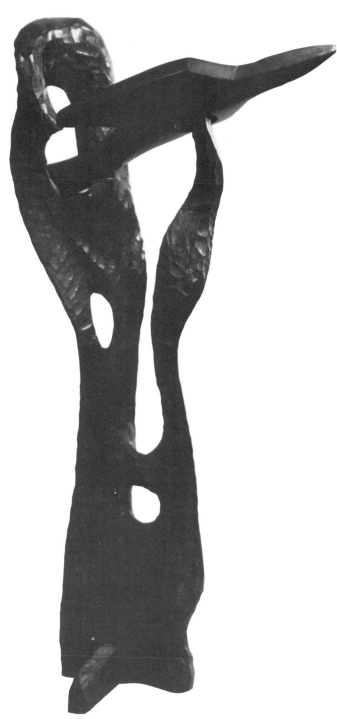

186. *Bird in Flight*. Ebony.

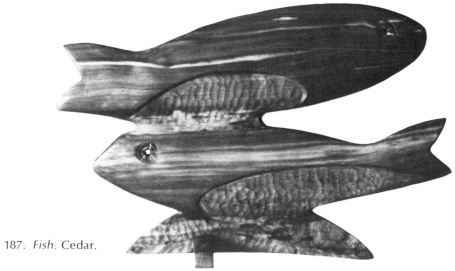

187. *Fish*. Cedar.

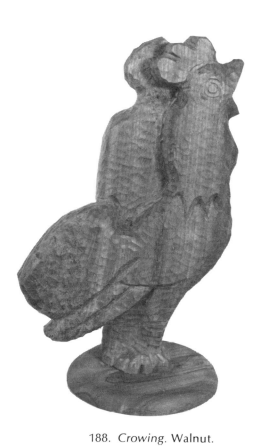

188. *Crowing.* Walnut.

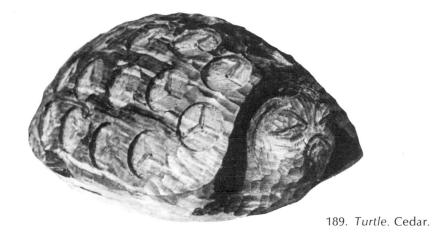

189. *Turtle.* Cedar.

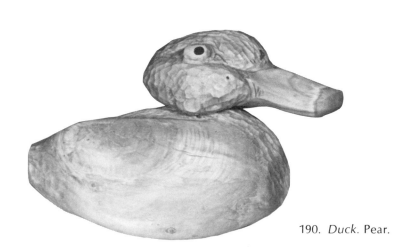

190. *Duck.* Pear.

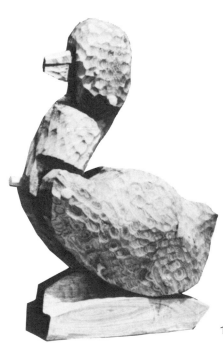

191. *Goose.* Butternut.

111

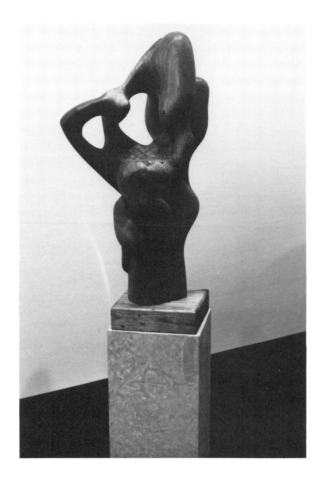

192. *Bird and Nest.* Butternut.

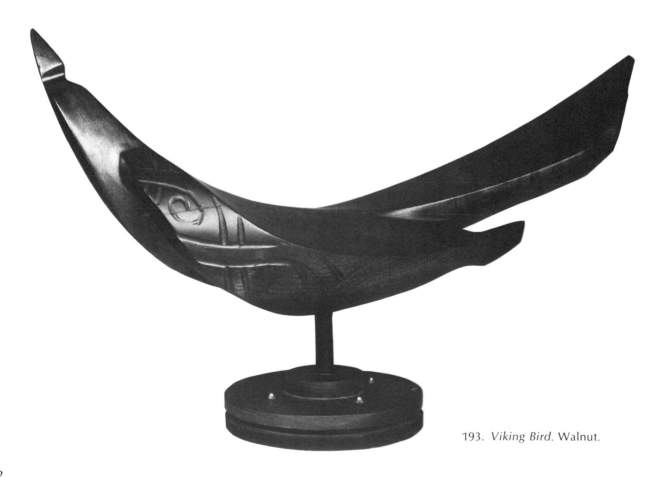

193. *Viking Bird.* Walnut.

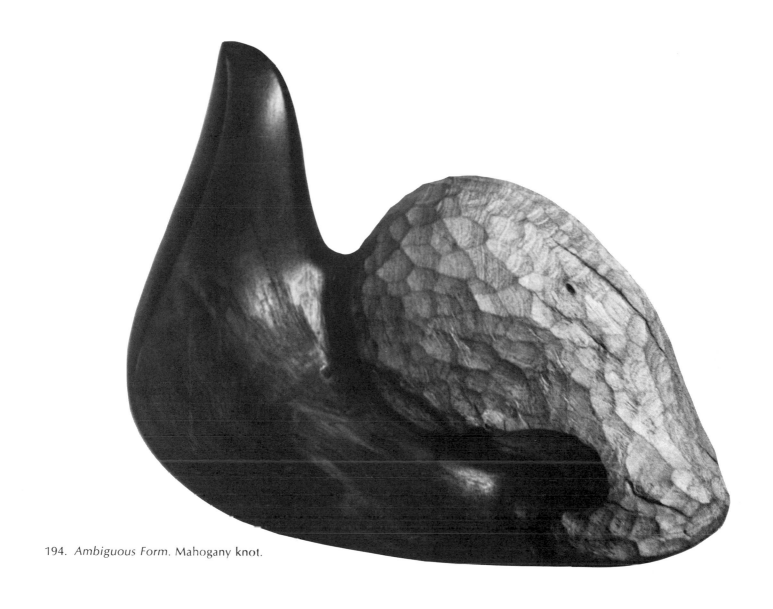

194. *Ambiguous Form*. Mahogany knot.

195. *Horns*. Rosewood.

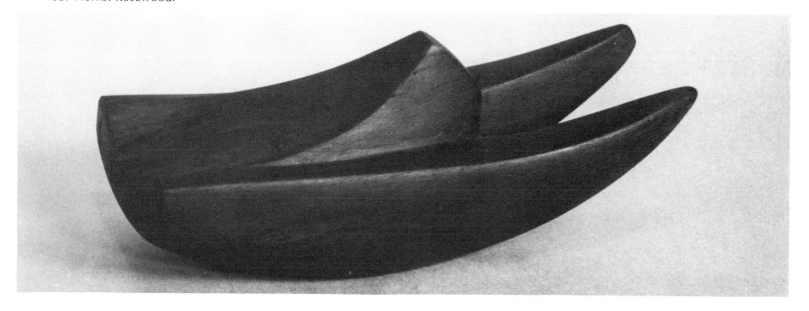

196. *Textured Form.* Walnut.

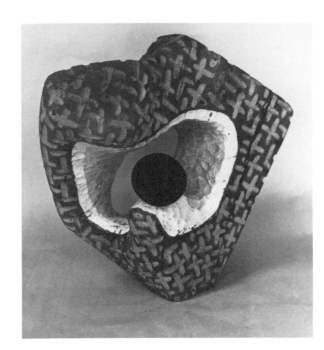

197. *Circularity.* Cedar.

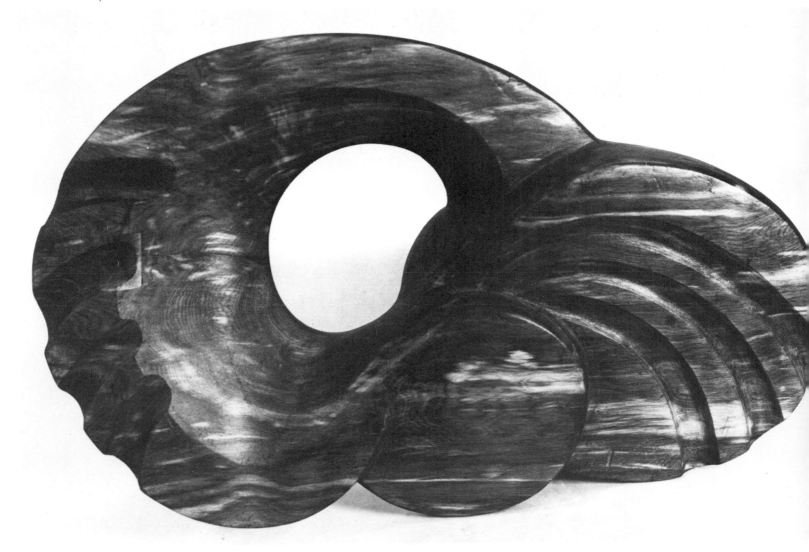

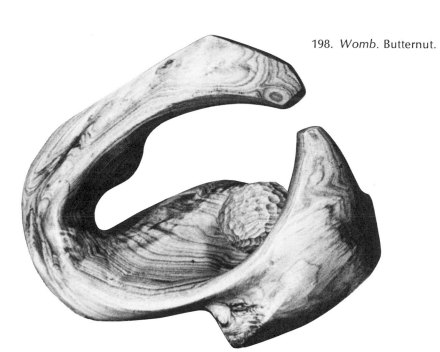

198. *Womb*. Butternut.

199. *Abstract Form*.
Unidentified wood from Brazil.

200. *Hand-shaped Form*. Mahogany.

201. *Mountain Form*. Arizona ironwood.

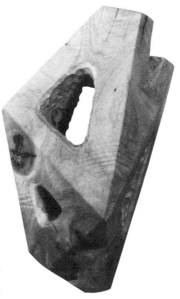

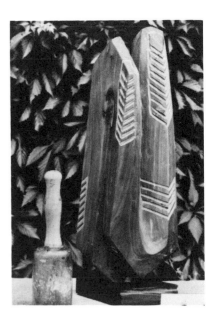

202. *Triangular Form*. Condalia.

203. Far right: *Tree with Texture*. Cedar.

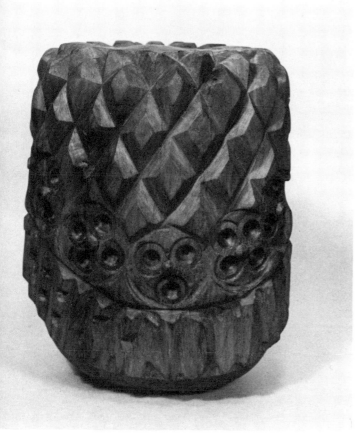

204. *Fruit Symbol*. Pear.

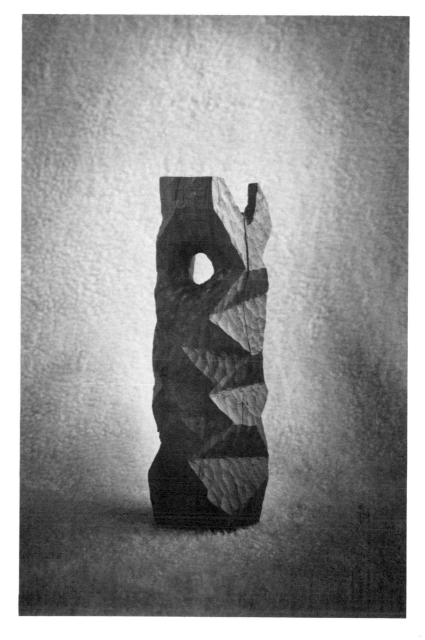

205. *Abstraction*. Texas ebony.

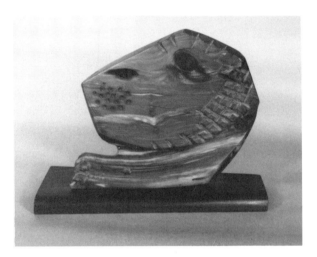

206. *Lion's Head.* Cedar.

207. *Three Blocks.*
Texas ebony.

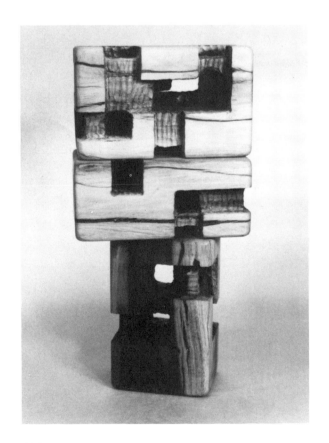

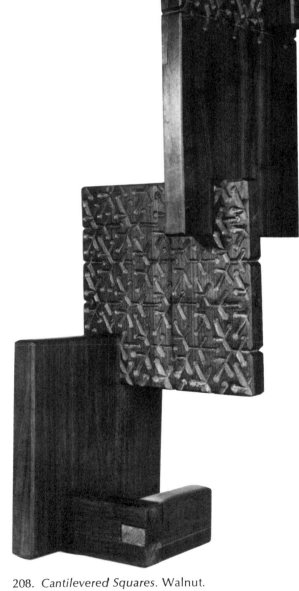

208. *Cantilevered Squares.* Walnut.

209. *Blocks*. Teak.

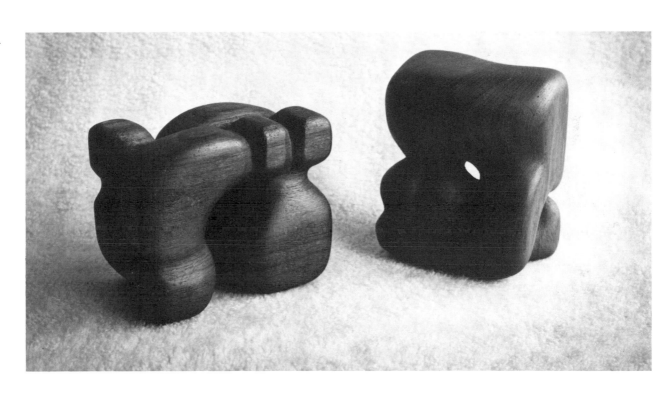

210. *Handling Piece (cobra)*. Condalia.

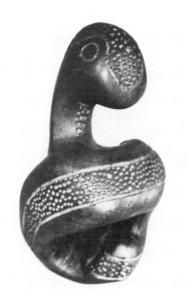

211. *Hand-shaped Form*. Walnut.

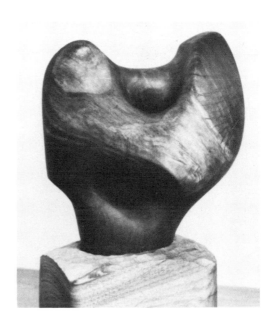

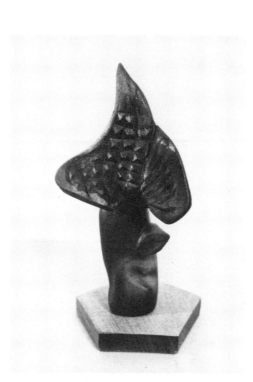

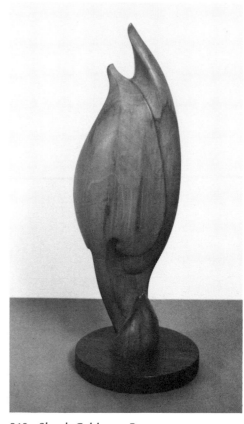

212. *Desert Plant*. Arizona ironwood.

213. *Skunk Cabbage*. Pear.

214. *Taking Off*. Butternut.

215. *Plant Form*. Cedar.

216. *Baroque Form*. Teak.

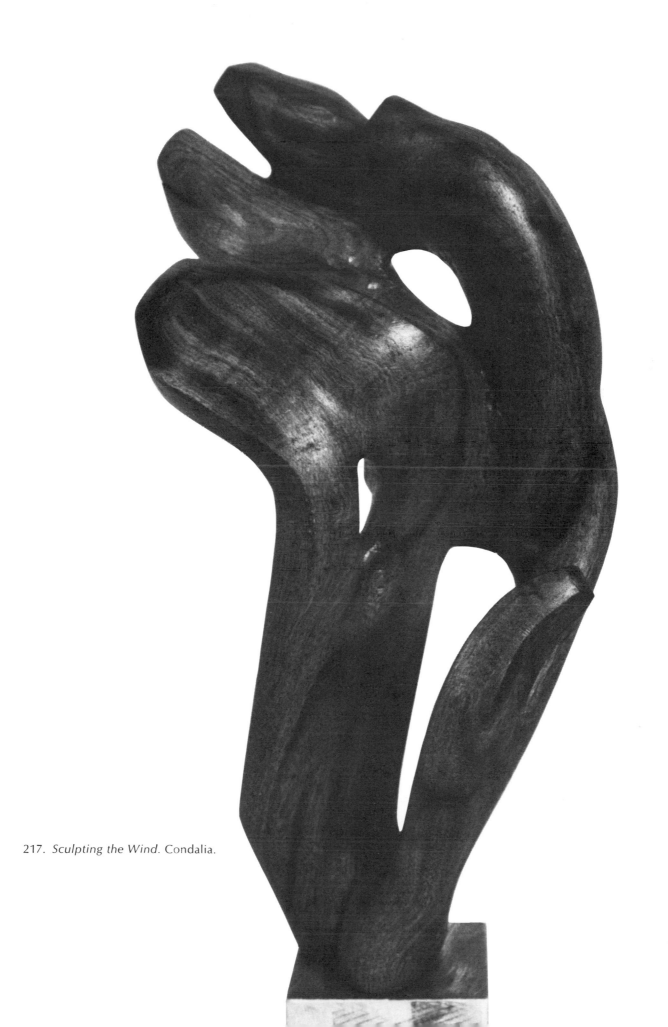

217. *Sculpting the Wind.* Condalia.

121

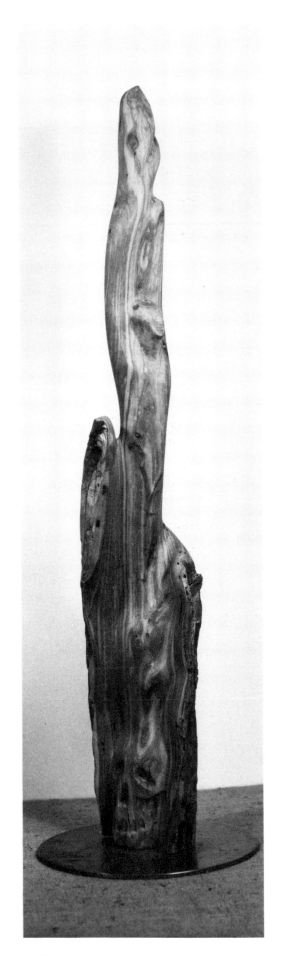

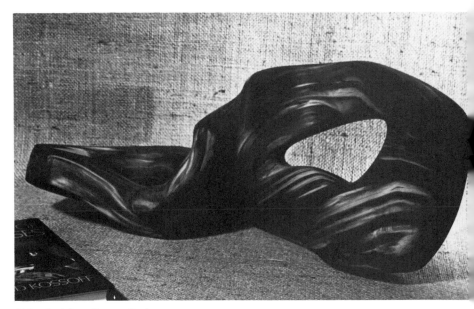

219. *Swirling Form*. Cedar.

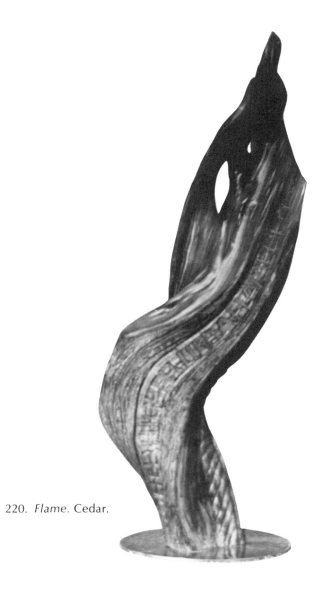

220. *Flame*. Cedar.

218. *Ecclesiastes 12:7*. Cedar.

LIST OF ILLUSTRATIONS

35. *Parable of the Sower.* Pulpit. A cylindrical form of laminated oak. The all-over high relief gives an enrichment which contrasts with the other interior surfaces. St. Paul's Lutheran Church, La Crosse, Wis.

36. *A Cloud of Witnesses.* Vinje Lutheran Church, Willmar, Minn. The entire interior is a symbolic expression of Hebrews 12:1-2. It becomes a visual symbol of the continuity and tradition-making of the people of God.

37. Four Advent panels. Laminated oak. Vinje Lutheran Church, Willmar, Minn. Candles are placed on a metal strip at the base of the panels.

38. *I Am the Vine.* Reredos of laminated white oak. Trinity Lutheran Church, Moorhead, Minn. Dimensions approximately 8 feet wide and 35 feet high. The three circular carvings are taken from the 15th chapter of the Gospel of John. The carving was done during the construction of the church and was designed as an integral part of the interior. The sculptor's son, Robert, worked with his father on this project.

39. Chancel screen with oak relief carvings. Trinity Lutheran Church of Minnehaha Falls, Minneapolis, Minn.

40. Details of chancel reliefs. Right: *Resurrection.* Below: *Redemption.* Pastor Conrad requested two Bible passages: John 1:29, *Behold the Lamb of God which taketh away the sin of the world;* and 1 Peter 1:3, *Born anew unto a living hope by the resurrection of Jesus Christ from the dead.* The baptismal font is placed in line with the vertical resurrection panel.

41. *Twenty-third Psalm.* Three panels are set at intervals in the walnut paneled lobby of the new Municipal Hospital in Jackson, Minn. This was a memorial to Mr. Watland.

42. Lettering in chancel area. Altar of oak. First Lutheran Church, Eau Claire, Wis.

43. Resurrection symbol. Kasota stone. Stress is on linear expression of symbol. First Lutheran Church, Duluth, Minn.

44. *Lord's Prayer.* Reredos of Kasota stone. First Lutheran Church, Duluth, Minn. Pastor Arthur Hanson requested the sculptor to serve as architectural consultant, particularly for the interior of the worship area. The Lord's Prayer, executed while the church was under construction with the help of John Maakestad, and the Beatitudes spaced along the side walls of the nave materialized from this assignment.

45. *Beatitudes.* Kasota stone. Nave side wall inserts in First Lutheran Church, Duluth, Minn.

46. Trinity Lutheran Church, Hovland, Minn. The church was in process of design by the sculptor during the construction. E. A. Sovik contributed the plan for the cantilevered roof and St. Olaf students and members of the Hovland Lutheran congregation gave three summers of labor to the project. The crew used the Dr. Hong jeep to pick up stones along the highway for the masonry.

47. Altar. Holden Village, Chelan, Wash. Holden is situated in the Cascade Mountains on the site of an abandoned copper mine. Large fir beams in good condition are scattered around the mine area. These were used to put together an altar, designed to hold together without nails or bolts.

48. Tympanum over front entrance. Indiana limestone. Immanuel Lutheran Church, Forest City, Iowa.

49. Psalm 100:4-5. *Enter His Gates with Thanksgiving. . . .* Oak doors of Trinity Lutheran Church, Clinton, Minn. The letters are placed at an angle to make stronger lights and shadows and break the flat surface of the doors.

50. *The Good Shepherd.* Wrought iron with cedar inserts. Exterior wall of Good Shepherd Lutheran Church, International Falls, Minn.

51. Brick relief of the Good Shepherd worked from brick layers using a scaled plaster model. Good Shepherd Lutheran Church, Rock Island, Illinois.

52. *Samuel.* Wrought iron and mahogany. Our Savior's Lutheran Church, Austin, Minn. Placed in hall of educational unit. The child Samuel is listening to God's call.

53. Symbol of hands receiving the gospel message. Kasota stone relief. Our Savior's Lutheran Church, Austin, Minn.

54. Six laminated mahogany panels placed on the brick wall behind the altar depict the passion and resurrection. The name of the church suggested the theme. Calvary Lutheran Church, Grand Forks, N.D.

55. *First Article of the Creed.* Lake Edge Lutheran Church, Madison, Wis. The church has a fine nature setting next to a lake. The four outside doors seemed an appropriate place to emphasize the Christian view of creation. There is a progression of the carved reliefs from the whirling spheres through aquatic and bird life, to flora and fauna, ending with man.

56. The three symbols cover the activity of the Trinity: creation, redemption, and the continuing presence of the Spirit. Grace Lutheran Church of Deephaven, Wayzata, Minn.

57. Symbol above entrance of Art Department, Texas Lutheran College, Seguin, Texas. The eye opens up in many directions.

58. Advent processional screen. Laminated oak with dovetailed joints. Central Lutheran Church, Minneapolis, Minn. This is a large church and the Advent symbol needed a size and pattern in scale with the interior. The brass candleholders were made by Bill Wilcox of Wayzata who does superb work with this metal.

59. Church pews. *I am* theme. Every fifth pew down center aisle of First Lutheran Church, Williston, N.D. Pastor Casper Nervig was concerned that there should be visible evidences of the Word. The carved pew ends helped carry out this purpose.

60. *Partial Description of Man.* Walnut. Lutheran Brotherhood Building, Minneapolis, Minn. The sculptor was given the chance to select both the subject matter and location of the panel. The location in the dining area off the garden court had good cross lighting and a delightful setting. The squares deal with man in some of his unlimited expressions.

61. *Parable of the Empty Room.* Matt. 12:43-45. A critique of those who attempt moral reformation instead of regeneration. Collection of Trinity Lutheran Church, Moorhead, Minn.

62. Job 38:1-2. *God answering Job out of the Whirlwind.* This is an exciting piece of end-grain laminated mahogany. Placed in the reception room of St. John's Lutheran Church, Northfield, Minn.

63. *The Generations Together*. Laminated walnut. Lutheran Home of the Good Shepherd, Havre, Mont. Psalm 148:12-13 is the theme of the relief which hangs on a brick wall in the lobby of the home.

64. Mark 4:28. Polychromed white pine placed on the wall behind the font in Zion Lutheran Church, Dysart, Iowa.

65. *Spreading the Message*. Oak. Above exit at Trinity Lutheran Church, Moorhead, Minn.

66. *Zacchaeus*. Sycamore wood from Oregon. Collection of Mr. and Mrs. David Pixley.

67. *Barren Fig Tree*. Luke 13:6-9. Myrtle. Collection of Mr. and Mrs. M. Haltey.

68. *Parable of the Sower*. Three laminated walnut panels. Narthex of Olivet Lutheran Church, Fargo, N.D.

69. Three relief carvings in Como Park Lutheran Church, St. Paul, Minn. *Zacchaeus in Sycamore Tree,* symbol of curiosity, entrance to chapel; *Ten Lepers,* symbols of gratitude, entrance to chapel, oak; *David with a Harp, Composer of Psalms,* in the choir room, mahogany.

70. Gold-leafed dove symbol above font. St. John's Lutheran Church, Northfield, Minn. This unusual photo was taken by Fred Gonnerman, editor of the alumni magazine, St. Olaf College.

71. *Rejoice in the Lord,* Philippians 4:4. Placed in the narthex on a wall of birch paneling in the Lutheran Church, Spicer, Minn.

72. *Good Friday Meditation*. Walnut. Collection of Mr. and Mrs. James Cederberg.

73. *Jesus at the Door*. Walnut. Bethlehem Lutheran Church, Aberdeen, S.D.

74. *Jesus at the Door*. Walnut. Collection of Mr. and Mrs. Ernie Holman.

75. *Door Ajar*. Cedar. There is much symbolism attached to a door or a gate. Collection of Mr. and Mrs. Henry Helgen.

76. *Isaiah 53:2*. Olive wood from Bethlehem, contributed by the sculptor's granddaughter, Kristen. Collection of Mr. and Mrs. Robert Flaten.

77. *Genesis. Spiral of Creation*. Walnut. One of the sketches for the St. Olaf Science Center lobby sculpture. Collection of Sidney A. Rand.

78. *Psalm 27*. Mesquite. Collection of sculptor.

79. *Jeremiah 8:11*. Pear. "They dress my people's wound, but skin-deep only." Collection of Luther Theological Seminary.

80. *Abraham*. Wood from Tanzania. Collection of Mr. and Mrs. Albert Finholt.

81. *Cain*. Walnut. Collection of Mr. and Mrs. Eric Nelson.

82. *Abraham*. Butternut. Collection of Mr. and Mrs. Loyal Golf.

83. *Jeremiah 9:1*. Walnut. Collection of Mr. and Mrs. V. Sielaff.

84. *Moses and the Two Tables of the Law*. Walnut. Collection of Mr. and Mrs. Ansgar Sovik.

85. *Jacob's Ladder*. Honduras mahogany. Honduras mahogany has unusually rich color. Collection of Mr. and Mrs. Paul Hanson.

86. *Jacob's Ladder*. Teak. Collection of Mr. and Mrs. E. A. Sovik. This has been a subject of several sculptures by the sculptor; probably influenced by his reading of Nygren's book, *Agape and Eros*.

87. *Job and his Miserable Comforters*. Collection of Tim Hengst. Tim acquired this piece during his senior year at California Lutheran College where he graduated as an art major with honors.

88. *Jonah*. Olive. Collection of Mr. and Mrs. Jerry Swanson. Jerry is chaplain of California Lutheran College and has charge of an office in the center of the campus, open 24 hours a day, called "The Belly of the Whale."

89. *Moses on Mt. Nebo*. Pear. Collection of Mr. and Mrs. Loyal Golf.

90. *De Profundis*. California walnut. Collection of Mr. and Mrs. Douglas Koons.

91. *Peter and Rooster*. Butternut. Collection of Mr. and Mrs. Loyal Golf.

92. *Three Views of the Cross*. Cedar. Collection of Mr. and Mrs. Marshall Pechauer.

93. *Peter*. Cedar. Collection of sculptor.

94. *Hosanna*. Pear. Collection of Genevieve Hilleboe.

95. *Faith*. Cedar. Collection of Mr. and Mrs. Engstrom.

96. *Hope*. California walnut. Collection of Elaine Tracy.

97. *Prophet*. Myrtle. Collection of Mr. and Mrs. Thomas Herbranson.

98. *Benedictus*. Arizona ironwood. Collection of Mr. and Mrs. Lee Fossum.

99. *Fruit of the Spirit*. Gal. 5:22. Padauk. Collection of Evelyn Flaten.

100. Psalm 19. *The heavens declare the glory*... Walnut. Collection of Ella Hjertaas Roe.

101. *Fruit of the Spirit*. Padauk. Collection of Mr. and Mrs. Maurice Knutson.

102. *Agape*. Polychromed oak with two panels that swivel. Love to God and neighbor. Collection of Mr. and Mrs. Donald R. Jorgensen.

103. John 7:38. *Rivers of Living Water*. Walnut. Collection of Mr. and Mrs. Ron Hemstad.

104. John 7:38. *Rivers of Living Water*. Orange. Collection of Mr. and Mrs. Jack Ledbetter.

105. *Seek His Kingdom*. Laminated walnut. Panel on wall above fireplace. Collection of Mr. and Mrs. Oscar Husby.

106. *Table Prayer*. Psalm 145:16. Butternut. Collection of Mr. and Mrs. E. Clifford Nelson.

107. *I Am the Vine, You Are the Branches*. Walnut. Collection of Mr. and Mrs. Paul Hanson.

108. *Prayer*. Walnut relief. Collection of Mr. and Mrs. Robert Bailey.

109. *More Light! Walnut*. One of the sketches for the Science Center lobby project. Collection of Mr. and Mrs. Robert Morrow.

110. *Stars.* Walnut. Another sketch for the Science Center lobby project. Collection of Mr. and Mrs. Thomas Rossing.

111. *White Pine Industry.* White pine. Collection of Agnes Larson, author of a book on the white pine industry.

112. *Benediction.* Rosewood. This rosewood from Madagascar is very dark and has been called ebony. Collection of Evelyn Jerdee.

113. *Fruit of the Spirit.* Walnut panels above fireplace. Home of sculptor.

114. *Lenten Message.* Walnut. Collection of Mr. and Mrs. David Thompson.

115. *King Olav.* Walnut. Collection of Mr. and Mrs. C. M. Granskou.

116. *Viking King.* Polychromed pine. Collection of Mr. and Mrs. William Narum.

117. *A Tear Is an Intellectual Thing.* (Blake quotation). Butternut.

118. *A Tear Is an Intellectual Thing.* Quotation from Blake. Myrtle. Collection of Mr. and Mrs. Casper Nervig.

119. William Blake's *Tyger.* Polychromed fir. Collection of Mr. and Mrs. Lee Fossum.

120. *Icarus.* Walnut. Collection of the sculptor.

121. *Version of Laocoon.* Walnut. Collection of Mr. and Mrs. John R. Winsor.

122. *Tension.* Walnut. Collection of Arnold Nash.

123. *Tension.* Myrtle. Tension is considered by some as the normal condition of western man. Collection of Mr. and Mrs. Kenneth Ducat.

124. *Current.* Indiana cedar. Collection of Mr. and Mrs. Paul C. Johnson.

125. *The Persuaders.* Cedar. One of a number of tension pieces. Collection of sculptor.

126. *Aaron, Moses, and Hur.* Cedar. Collection of sculptor.

127. *Protest Marcher.* Walnut. A common theme during the sixties. Collection of sculptor.

128. *Looking.* Walnut. The two figures by windows are suggestive of many human situations. Collection of Mr. and Mrs. Albert Anderson.

129. *Leaving the Group.* Walnut. Collection of sculptor.

130. *Schizo.* Butternut. Collection of Mr. and Mrs. Howard Hong.

131. *Watchmen.* Pear. Collection of sculptor.

132. *Paul Ricoeur.* Cedar. Symbol suggested by his book, *The Symbolism of Evil.* Collection of sculptor.

133. *Climbers.* Cedar. A much repeated theme of the sculptor. Collection of sculptor.

134. *Climbers.* Walnut. Collection of Mr. and Mrs. David Flaten.

135. *Breaking Out of the Circle.* Walnut. Collection of Mr. and Mrs. Howard Hong.

136. *Wanderer and Dog.* Walnut. Collection of sculptor.

137. *Rockhopping in the Rockies.* Walnut. Collection of Margaret Bailey.

138. *Joy.* Walnut with movable parts. Collection of Mr. and Mrs. Michael Thomas.

139. *Chinese Acrobat.* Walnut. Idea suggested by TV show of visiting Chinese acrobats. Collection of Mr. and Mrs. William Narum.

140. *The Dancer.* Laminated mahogany. "The fruits of the Spirit are love, joy, peace." Collection of Mr. and Mrs. Maurice Knutson.

141. *Balance.* Pear. Collection of sculptor.

142. *I Am.* Teak. The I AM is rather cryptically placed on the cube, being held high. The grain of the teak is unusually expressive. Collection of Judy Grosfield.

143. *Balance.* Walnut. Balance is another recurring theme. Collection of Mr. and Mrs. Maurice Knutson.

144. *The Librarian.* Laminated walnut. Collection of Evelyn Flaten.

145. *Teacher.* Oak. Collection of Mr. and Mrs. Albert Finholt.

146. *Sadness.* A beautifully grained, deep red wood from Brazil. Collection of Mr. and Mrs. Maurice Knutson.

147. *Introspection.* Walnut.

148. *Figure.* Walnut. Collection of Mary Flaten.

149. *Frustration.* Walnut. Collection of Mr. and Mrs. Luther Nervig.

150. *Self-assurance.* Walnut. Collection of Mr. and Mrs. Maurice Knutson.

151. *Marriage.* Mahogany. Collection of Mr. and Mrs. David Wee.

152. *Load.* Myrtle. Collection of Mr. and Mrs. Maurice Knutson.

153. *Urgency of Message.* Cedar. Collection of Mr. and Mrs. E. Clifford Nelson.

154. *Dietary Piety.* Pear. Collection of sculptor.

155. *Despair.* Cedar fence post. The knot suggested the idea and was left uncarved. Collection of Mr. and Mrs. Douglas Koons.

156. *The Griper.* Butternut. Collection of sculptor.

157. *Negotiating.* Walnut. This piece was made during the Paris peace negotiations. Collection of the sculptor.

158. *Thinking (whatever that is).* Teak. Inspired by watching a game of chess on TV. Collection of Mr. and Mrs. T. Schoenherr.

159. *Listening Through a Crack in the Wall.* Walnut. Another symbol taken from Dostoievski's *Notes From the Underground.* Collection of Mr. and Mrs. Lee Fossum.

160. *The Perfectionist.* Butternut. Owner unknown.

161. *The Dreamer.* Mesquite. Collection of Mr. and Mrs. Norman Couper.

162. *The Egghead.* Myrtle. Collection of Mr. and Mrs. Albert Anderson.

163. *Eating Crow.* Walnut root. A literal expression of the idiom. Collection of sculptor.

164. *Troll.* Cedar. Collection of Mr. and Mrs. David Wee.

165. *Three Faces*. Monkeypod. At the bottom, an infant's face. Above, two mature faces of different character. Collection of Mr. and Mrs. Clint Sathrum.

166. *Promethean Symbol*. Texas cedar. Collection of sculptor.

167. *Hand*. Walnut. Collection of Mr. and Mrs. C. M. Granskou.

168. *Gambler's Hand*. Myrtle. Collection of Dorothy Divers.

169. *Lowering the Boom*. Walnut. Collection of Mr. and Mrs. Harry Keller.

170. *Teamwork*. Walnut. Collection of Mr. and Mrs. Edward Brooks Jr.

171. *Beyond the Moon*. Walnut. Collection of Gertrude Hilleboe.

172. *Struggle*. Cedar. Collection of Mr. and Mrs. Robert Morrow.

173. *Escape*. Laminated oak. Collection of Mr. and Mrs. David Flaten.

174. *Yin-Yang*. Butternut. Symbol of the complementarity of life's patterns. Collection of sculptor.

175. *Family*. Texas ebony. A local wood collector, Fran Hall, introduced this elegant, colorful wood to the sculptor. Collection of the sculptor.

176. *Piggyback*. Walnut. Owner unknown.

177. *Mother and Child*. Texas ebony. Texas ebony is one of the finest carving woods in the U.S.A. Collection of Mr. and Mrs. T. Schoenherr.

178. *Mother and Son*. Oak. Collection of Mr. and Mrs. Orville Perman.

179. *Dr. C. M. Weswig*. Bronze relief. Collection of Luther Theological Seminary, St. Paul, Minn. Dr. Weswig was one of the sculptor's favorite teachers.

180. *Anne Kellner*. Pear wood. Anne (Jacobson) Kellner, close friend of Evelyn Flaten, spent the summer of 1931 in Paris. M. Jean Camus claimed that American pear was the finest carving wood. The result was the selection of this medium for the portrait.

181. *Evelyn Flaten*. Carrara marble. This was done during the period in Paris in the studio of M. Jean Camus. 1931, collection of sculptor.

182. *Form in Motion*. Walnut. Collection of Mr. and Mrs. James Enestvedt.

183. *Two Birds Feeding*. Mahogany relief. Collection of Mr. and Mrs. Kenneth Jennings.

184. *Cardinal*. Walnut. Collection of Mr. and Mrs. Orin Lofthus.

185. *The Pecking Order*. Walnut. Collection of Mr. and Mrs. Harry Keller.

186. *Bird in Flight*. Ebony. Collection of Mr. and Mrs. Reidar Dittmann.

187. *Fish*. Cedar. Owner unknown.

188. *Crowing*. Walnut. Collection of sculptor.

189. *Turtle*. Cedar. Collection of Mr. and Mrs. David Wee.

190. *Duck*. Pear. The head swivels. Collection of Mr. and Mrs. Robert Morrow.

191. *Goose*. Butternut. A humorous version with two joints in the neck and a rocking base. Collection of sculptor.

192. *Bird and Nest*. Butternut. A large piece placed on a podium of Kasota stone in church library. Collection of Good Shepherd Lutheran Church, Minneapolis, Minn.

193. *Viking Bird*. Walnut. Collection of sculptor.

194. *Ambiguous Form*, a handling piece. Mahogany knot. Collection of Mr. and Mrs. Maurice Knutson.

195. *Horns*. Rosewood. Collection of sculptor.

196. *Textured Form*. Walnut. Collection of sculptor.

197. *Circularity*. Cedar. Collection of Mr. and Mrs. David Johnson.

198. *Womb*. Butternut. Collection of Mr. and Mrs. Maurice Ness.

199. *Abstract Form*. Wood from Brazil. Collection of Joann Hoeft.

200. *Hand-shaped Form*. Mahogany. Collection of Mr. and Mrs. Maurice Knutson.

201. *Mountain Form*. Arizona ironwood. Collection of sculptor.

202. *Triangular Form*. Condalia. Collection of sculptor.

203. *Tree with Texture*. Cedar. Collection of Mr. and Mrs. William Brodersen.

204. *Fruit Symbol*. Pear. Lettering is from Matt. 7:17. Collection of Mr. and Mrs. Christopher Lind.

205. *Abstraction*. Texas ebony. Collection of Mr. and Mrs. Maurice Knutson.

206. *Lion's Head*. Cedar. Collection of sculptor.

207. *Three Blocks*. Texas ebony. Collection of sculptor.

208. *Cantilevered Squares*. Walnut. All over arabesque is taken from a Persian design. Collection of sculptor.

209. *Blocks*. Teak. Collection of Mr. and Mrs. Maurice Knutson.

210. *Handling Piece (The Benevolent Cobra)*. Condalia. Condalia is an unusually hard wood found in the Texas area. It finishes with a very rich color. Collection of sculptor.

211. *Hand-shaped Form*. Walnut. Owner unknown

212. *Desert Plant*. Arizona ironwood. Collection of sculptor.

213. *Skunk Cabbage*. Pear. Collection of Naida Knatvold Jenson.

214. *Taking Off*. Butternut. Collection of sculptor.

215. *Plant Form*. Cedar. Collection of Joseph Rokke.

216. *Baroque Form*. Teak. Collection of Mr. and Mrs. Arthur Paulson.

217. *Sculpting the Wind*. Condalia. Collection of Mr. and Mrs. Darrell Ostercamp.

218. *Ecclesiastes 12:7*. Cedar. Collection of Mr. and Mrs. Eric Nelson.

219. *Swirling Form*. Cedar. Collection of Darlene Erlander.

220. *Flame*. Cedar. A line from Shelley's *To a Skylark* has been added. Collection of Mr. and Mrs. Douglas Koons.

ACKNOWLEDGEMENTS

To Paul Johnson, former editor of the Prairie Farmer, who more than anyone else is responsible for this book; to Augsburg Publishing House and its staff; to Orin Lofthus, a neighbor who had charge of the major part of the photography; to son David Flaten who contributed a number of photographs; to all the individuals, churches, schools, and other institutions that supplied photographs; to the St. Olaf Art Department and its chairman John Maakestad for arranging my retrospective show in 1970 and two more recent ones; and to the many who added to my stockpile of wood, with special mention to Missionary Oliver Carlson who delivered an oil drum of Madagascar rosewood, to Maurice Knutson and Louis Grosfield for a plentiful supply of Montana and Texas cedar, and to wood collector friend Fran Hall whose rare woods keep moving across the river to my shop; to Bob Warn who worked with my wife in the collection of photos which eventually became the book; to Evelyn my wife who has given me an extra pair of critical eyes and is a constant source of encouragement and inspiration.

Not all of my work is pictured in this book because some pieces do not photograph well. A special word of appreciation to Karen Foget who chose from hundreds of available photographs those which best suited the requirements of printing and who designed the book.

Arnold Flaten